IMAGES
of Aviation

SELFRIDGE FIELD

D1496446

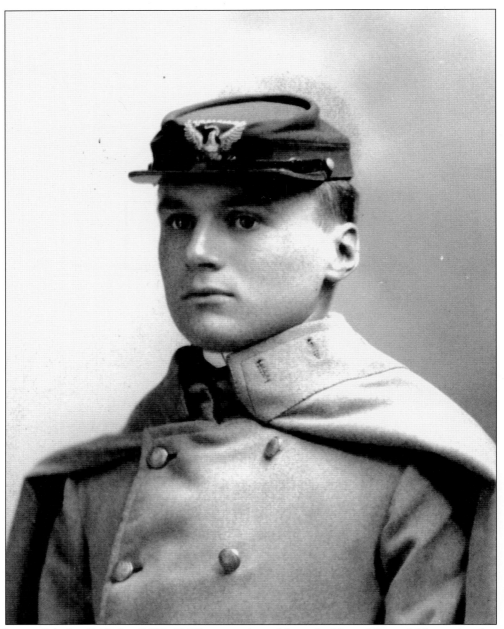

Thomas Etholen Selfridge (1883–1908) was graduated from the United States Military Academy at West Point with the class of 1903. He was 31st in a class of 96, ranked well below valedictorian Douglas MacArthur (1880–1964). After receiving his commission, Selfridge was assigned to the field artillery and then was attached to the U.S. Army Signal Corps, where he had an opportunity to explore the potentials of military aviation. (Courtesy of United States Military Academy Library.)

On the cover: Seversky P-35s are parked along the Selfridge Field flight line about 1937. (Courtesy of the Selfridge Military Air Museum.)

IMAGES
of Aviation

SELFRIDGE FIELD

Deborah J. Larsen
and Lt. Col. Louis J. Nigro

ARCADIA
PUBLISHING

Published by Arcadia Publishing
Charleston, South Carolina

Printed in the United States of America

Library of Congress Catalog Card Number: 2005938285

For all general information contact Arcadia Publishing at:
Telephone 843-853-2070
Fax 843-853-0044
E-mail sales@arcadiapublishing.com
For customer service and orders:
Toll-Free 1-888-313-2665

Visit us on the Internet at www.arcadiapublishing.com

To all of the Selfridge fliers who followed Thomas E. Selfridge boldly into the skies, and to all of the support personnel who gave them wings, this book is respectfully dedicated.

CONTENTS

ACKNOWLEDGMENTS

The authors gratefully acknowledge the writings of prior historians of Selfridge Field, the First Fighter Wing and the U.S. Air Force, whose work made our efforts easier, as well as the vision of the late Col. Robert A. Stone and the Michigan Air Guard Historical Association in establishing the Selfridge Military Air Museum to preserve the record of this venerable field.

Special thanks go to all of the volunteers of the Selfridge Military Air Museum who assisted with photograph sorting and selection, fact checking, and moral support, including Douglas Barbier, Jim Koglin, Mary Lou Pearsall, Frank Brown, Ed Stoll, Bernie Weideman, Don Hussey, Mark Bedsole, and Philip Handleman.

For contributing photographs, we are especially indebted to Hank and Phyllis Miller and Fred Prahl of Mount Clemens, Michigan; Douglas C. Siegler of Sterling, Virginia; John Swanson, 127th Wing Multimedia Services; Eric Brian, deputy chief of public affairs, 927th Air Refueling Wing; Elizabeth Clemens, audiovisual archivist at the Walter P. Reuther Library, Wayne State University; Jennifer Wood, archivist at the Clarke Historical Library, Central Michigan University; Alicia Mauldin-Ware of the Special Collections and Archives Division, U.S. Military Academy Library at West Point, New York; and the management of *The Macomb Daily* newspaper, Mount Clemens, Michigan.

This book would not have been possible without the support of the Board of Trustees and staff of Mount Clemens Public Library, and library director Donald E. Worrell Jr., whose vision launched the project.

All photographs used in this book are courtesy of the Selfridge Military Air Museum except as noted.

INTRODUCTION

"Stiffitis neckitis" is what a local newspaper editor called the condition afflicting the gawking citizens of Mount Clemens, Michigan, during the summer of 1917. The United States had lately entered World War I and had just established an airfield in the swampy lowlands between the city's eastern border and Lake St. Clair. Military aircraft piloted by members of the 8th and 9th Aero Squadrons were first seen aloft over the city on July 9, and the eyes of Mount Clemens's people turned heavenward in wonder.

More than eight decades later, the novelty has not worn off. Although Selfridge Field has gone through many incarnations, which have brought it from its birth as a fledging army airfield to its current role as an Air National Guard base, the heartbeat of an institution engaged in making history has never left it.

After successfully training more than 1,000 aerial gunners and hundreds of aircraft mechanics for service during World War I, Selfridge Field nearly closed during the post-Armistice draw down. Government advisers for aeronautical matters saw its potential value, however, and recommended the outright purchase of the installation in 1921. The following year opened a new and exciting chapter when the First Pursuit Group, a highly decorated organization which numbered among its members several World War I aerial aces, made Selfridge Field its new headquarters.

The pilots of the First Pursuit Group would spend the next two decades dazzling the local citizenry, and the world, with their aerial feats. They performed operational testing for dozens of new aircraft, competed boldly in air races, and set record after aviation record. They were the elite of the aviation world, a fact that is reflected in the number of famous names recorded in their squadrons' rosters. Gen. Curtis LeMay recalled in his memoirs his excitement when, as a young lieutenant with newly minted wings, he received orders for Selfridge Field and an opportunity to rub elbows with the "First Team." Gen. H. H. "Hap" Arnold commented that it was the ambition of every air corps pilot to serve at Selfridge.

The bombing of Pearl Harbor on December 7, 1941, precipitated the immediate departure of the First Pursuit Group and once again changed the mission of Selfridge Field. The new global conflict required mobilization on a scale never before seen, and Selfridge was soon bursting with raw recruits, who received basic training and assignment to newly formed units. The 332nd Fighter Group, known as the Tuskegee Airmen, attended advanced combat training at the field and went on to unparalleled success in escorting bombers safely to their targets.

Following the war, the dawn of the jet age afforded more opportunities for Selfridge pilots to make history. In 1948, sixteen F-80 jet fighters from the 56th Fighter Group demonstrated for

the Soviet Union and the world their ability to deploy quickly across the Atlantic when they completed the first west-to-east transatlantic jet crossing in just over nine hours. When war erupted in Korea, members of this organization were among America's first jet aces.

An initiative of the Air Defense Command named Project Arrow, which was an effort to return units to their historic bases, prompted the return of squadrons formerly part of the First Pursuit Group, now designated the First Fighter Wing, in 1955. Although the First Fighter Wing would remain at Selfridge for another 15 years, the base was already gradually entering another phase of its history, which would culminate in its transfer in 1971 from the U.S. Air Force to the Michigan Air National Guard. As it had done in 1917, Selfridge was once again serving as an exemplar of a new type of military installation. With the Michigan Air National Guard serving as the host organization, the base became the model of a successful joint-services facility, with units from all five branches of the armed forces represented within its gates and working in concert.

In a certain respect, Selfridge had come full circle, from the early days in 1917, when Company G of the 33rd Michigan National Guard secured the muddy field for the arrival of the army's first aero squadrons, to the day when its last air force commander "handed over the keys" to the Michigan Air National Guard. But in a larger sense, Selfridge is still moving forward, still making history, still evolving to meet the changing demand for air power. And as the century mark approaches, the neighbors are still looking up in wonder.

One

ORIGINS

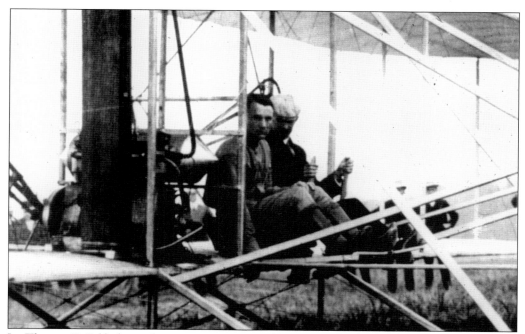

Lt. Thomas E. Selfridge and aviation pioneer Orville Wright (1871–1948) prepare to demonstrate the Wright Flyer for army officials at Fort Myer, Virginia, on September 17, 1908. Although Wright was somewhat distrustful of Selfridge and considered him a potential competitor in the emerging aviation field, he was nevertheless interested in a possible contract with the army and agreed to take the young Signal Corps officer as a passenger.

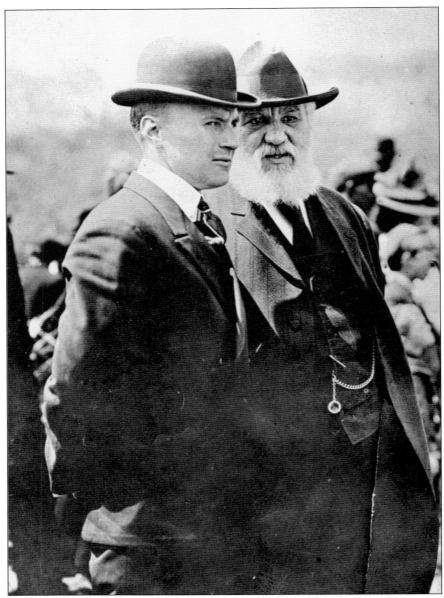

Telephone inventor Alexander Graham Bell (1847–1922) was also an early designer of experimental aircraft. Bell was chair of the Aerial Experiment Association (AEA), an organization for which Thomas Selfridge served as government liaison and secretary. Selfridge took his first heavier-than-air flight in Bell's tetrahedral kite, the Cygnet, on December 6, 1907. The seven-minute flight took place in Nova Scotia and reached an altitude of 168 feet. The following year, Selfridge designed the AEA's first airplane, called the Red Wing, which provided the first public demonstration of a powered aircraft in the United States.

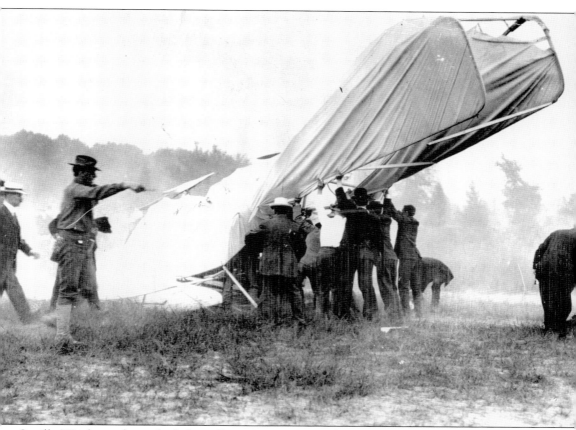

Orville Wright made a solo flight at Fort Myer on September 17, 1908, and decided to replace his propeller with a longer, untested version. During his next flight, with Thomas Selfridge as a passenger, the end of the propeller fell off and endangered the craft. To regain control, Wright shut off the engine and glided to a landing, but the flyer went into a nosedive as it touched the ground. Wright survived but was badly injured and spent months in recovery. Fatally injured, Lt. Thomas E. Selfridge became the first casualty of powered flight when he died in surgery hours after the accident.

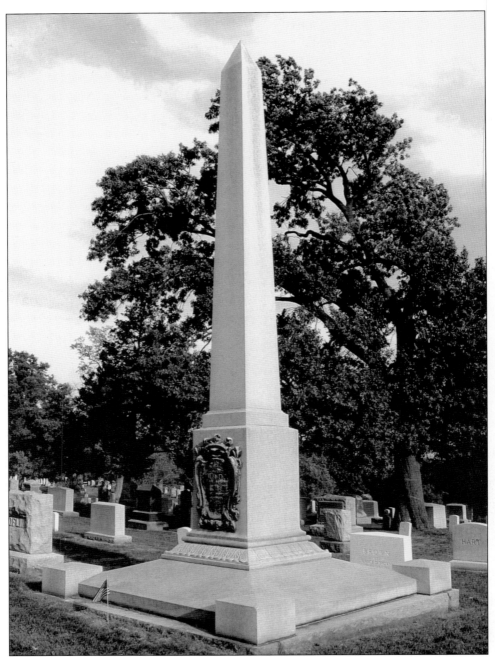

The grave site of Thomas E. Selfridge at Arlington National Cemetery in Virginia is adjacent to Fort Myer. Selfridge was buried there with full military honors on September 25, 1908. Friends of the young lieutenant lamented that a promising life had been cut short but noted that he had perished doing what he loved the most, in an attempt to speed advances in his chosen field. Selfridge's name is also immortalized on a cemetery gate, which is near the site of the fateful crash. Within a decade of his death, a new army airfield in Michigan would bear his name. (Courtesy of Douglas C. Siegler.)

Henry Bourne Joy (1864–1936), who started his career in the railroad industry, became interested in developing aircraft engines during his tenure as president of the Packard Motor Car Company. In November 1915, he began buying up mud flats along Lake St. Clair in Harrison Township, Michigan, eventually amassing more than 600 acres, which he named Joy Aviation Field. As World War I intensified, Joy, who had served aboard the USS *Yosemite* with the Michigan Naval Brigade during the Spanish-American War, foresaw the government's emerging need for military airfields. His overtures, along with the lobbying efforts of local officials, resulted in the lease of Joy Aviation Field for use as an army airfield in May 1917.

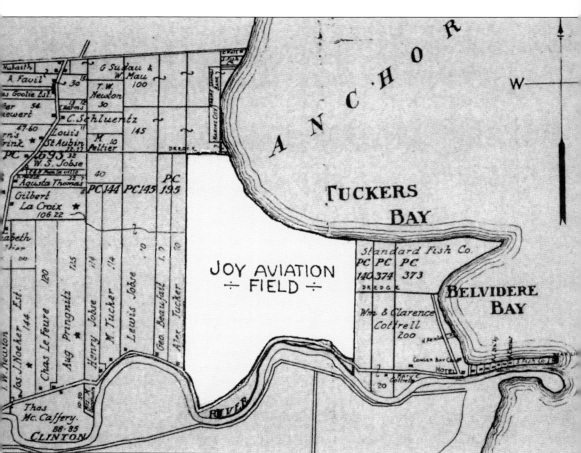

In the spring of 1917, Henry B. Joy and the Mount Clemens Business Men's Association set about convincing the War Department that the largely unimproved but strategically located Joy Aviation Field was an ideal place to establish a military airfield. The government was encouraged to consider the advantages of nearby Lake St. Clair for practice bombing, as well as the availability of mechanical and engineering expertise in the local automobile factories. The government officially took control of the field on July 1, 1917, and named it Selfridge Field in honor of the first military man to lose his life in a powered aviation accident.

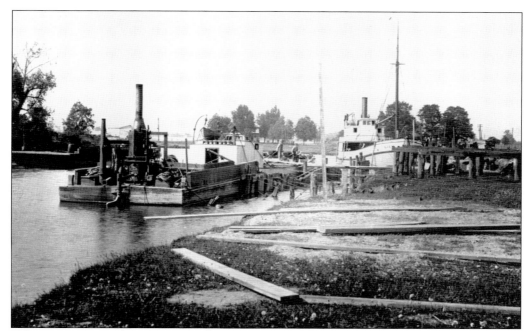

When construction began in May, the new aviation field was a sodden marsh. In places it was below lake level, and the ground was soggy at best. The only land route for the delivery of supplies was along River Road, which began to collapse under the heavy traffic. At first, bringing building supplies to the base by barge proved to be the most practical method of moving material.

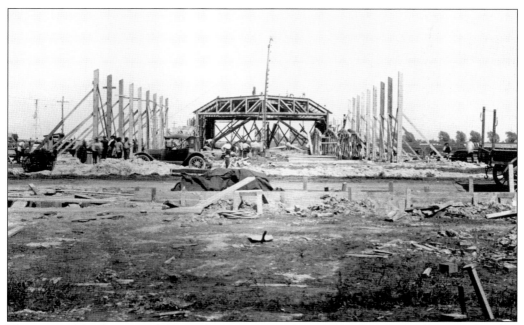

Vacant marshlands sprouted 12 new hangars during June 1917. More than 160 acres of timber were cleared, and logs were sawed on the spot for immediate use. Renowned industrial architect Albert A. Kahn (1869–1942) was hired to design many of the buildings for the new installation.

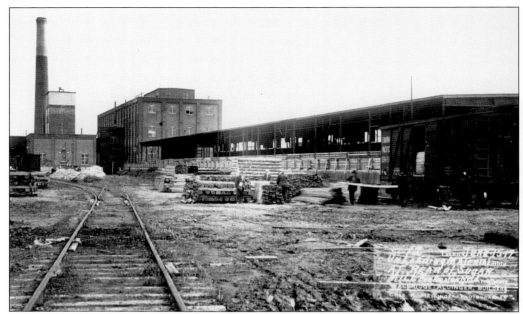

A new spur from the Grand Trunk Railway line to the aviation field was not completed until June. Until then, material shipped by rail was unloaded at the nearby Mount Clemens Sugar Company, shown here, and transferred by truck or barge to the field. Meanwhile, the laying of the railroad track proceeded apace across the farmers' fields, and issues of right-of-way were settled after the fact.

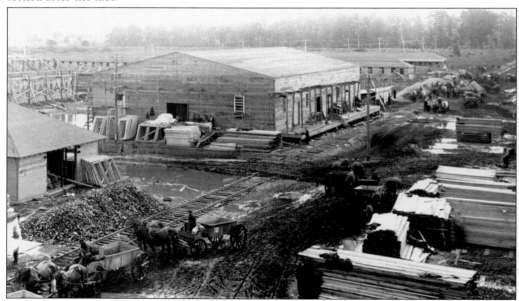

The new railroad spur expedited construction, but conditions at the site were still miserable. Large ponds of standing water are visible here, illustrating drainage challenges that would plague Selfridge until a seawall and underground drain system could be installed. The proximity of Lake St. Clair, presented to the government as an advantage of the field, turned out to be the first real threat to its success.

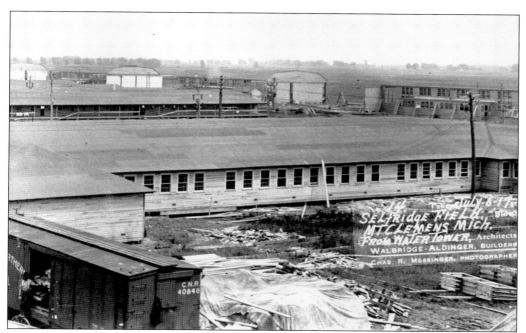

Approximately $1 million was spent on the development of Selfridge Field in the spring and summer of 1917. In addition to hangars, two repair shops, a school, six barracks, supply depots, machine shops, and headquarters buildings were erected and put into use by the 8th and 9th Aero Squadrons, components of which began arriving with their airplanes on July 7, 1917.

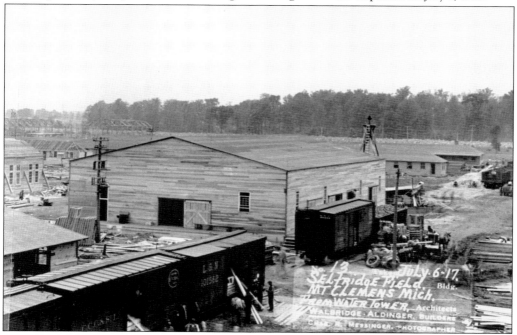

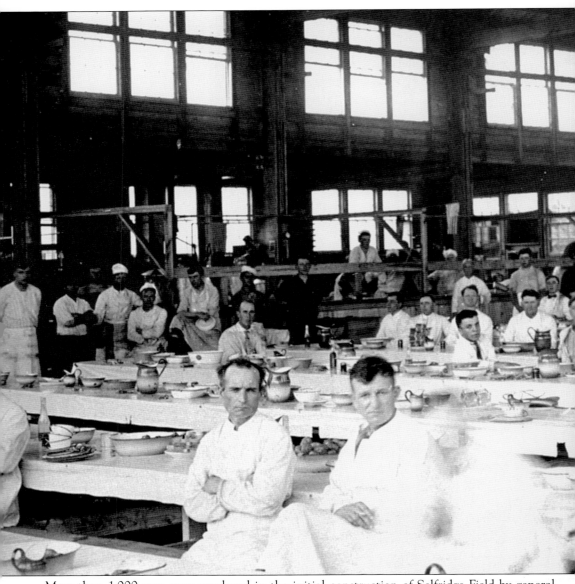

More than 1,000 men were employed in the initial construction of Selfridge Field by general contractor Walbridge Aldinger and others. Here the workmen are shown in the base's first mess

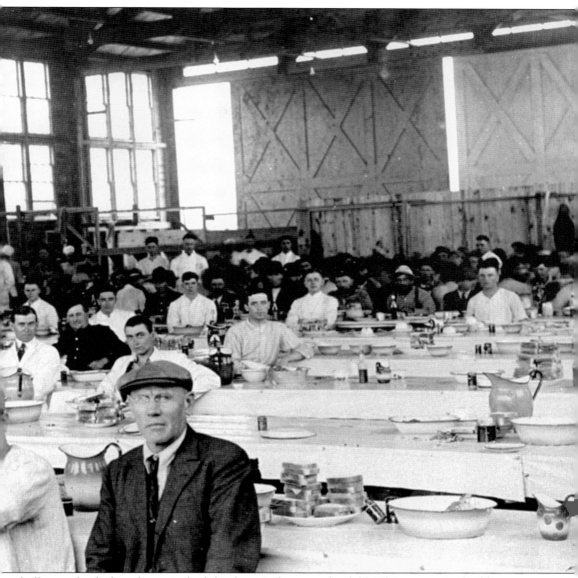

hall, one day before the arrival of the first airplanes at the field. This expansive building was later used as a hangar.

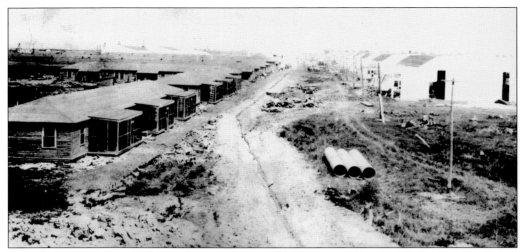

Selfridge's main street, Jefferson Avenue, is viewed looking east from the gate at Joy Boulevard as construction progressed in the summer of 1917. As no access road existed at the time the base was built, a straight, 100-foot-wide concrete thoroughfare was laid from Gratiot Avenue to Jefferson Avenue. At first named Aviation Road, it was later christened Joy Boulevard in honor of Henry B. Joy.

Early arrivals of army air service personnel in July 1917 pose with one of their airplanes, looking none too pleased with their somewhat rustic accommodations.

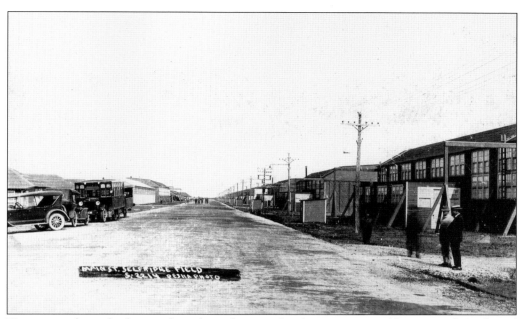

Two views along the hangar line show the completed construction. (Courtesy of Hank and Phyllis Miller.)

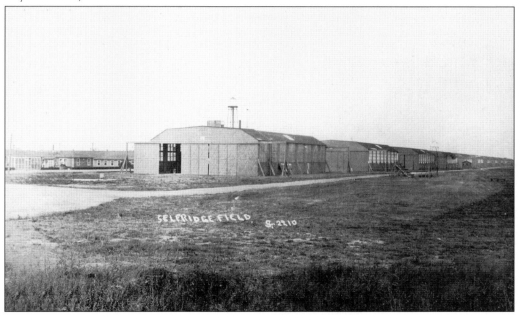

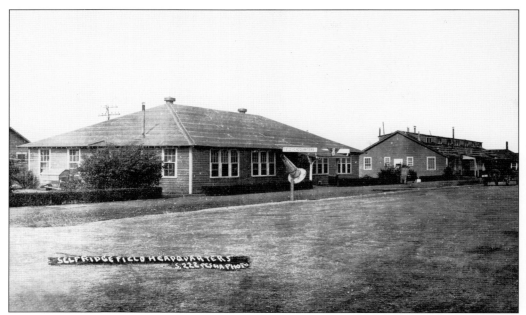

The post headquarters building is shown after construction was completed. (Courtesy of Hank and Phyllis Miller.)

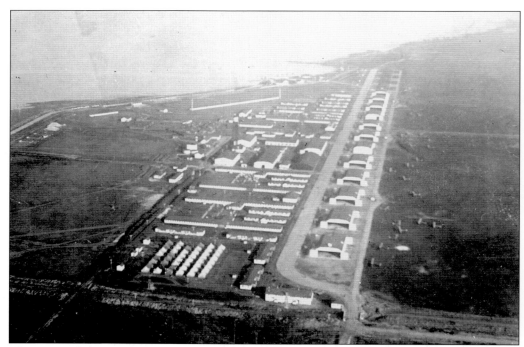

This view of the newly constructed Selfridge Field in 1918 looks east from 4,000 feet. Lake St. Clair is seen in the background, and numerous aircraft dot the field to the right of the hangar line in the center right of the photograph.

Two

THE PURSUIT AND AIR RACING YEARS

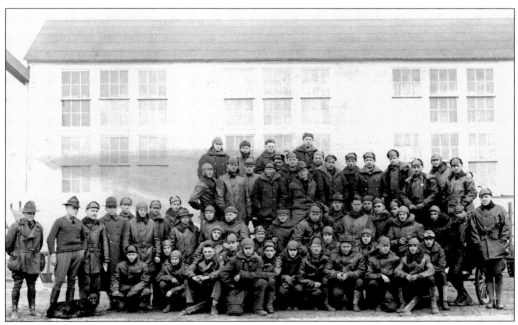

The field had been open less than six months when the harsh Michigan winter closed the flying school and sent the airplanes south for the season. In the meantime, Selfridge became home to a school for mechanics. Squadron B, shown here in front of the barracks in 1918, was formed from various detachments attending the mechanics' school.

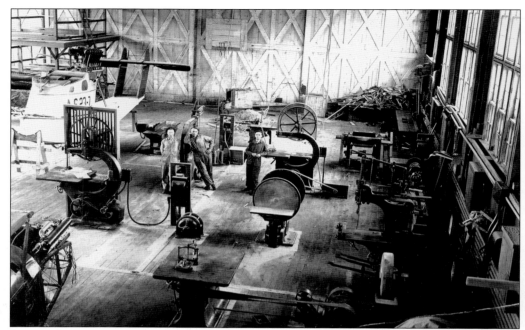

Six squadrons came north from Kelly Field, Texas, to attend the School of Mechanics at Selfridge, working in aero repair shops like this one. By March 1918, when the school was closed, it had graduated 700 enlisted men and qualified them as aircraft mechanics.

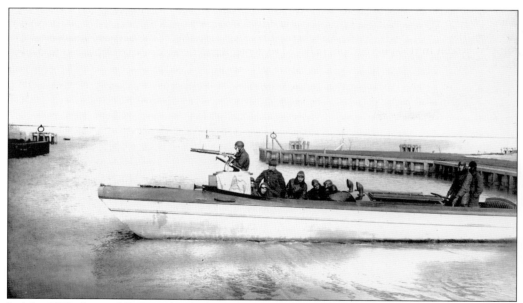

In May 1918, the world's first school of aerial gunnery was established at Selfridge Field under the command of Maj. Frank D. Lackland (1884–1943). The field's location on a waterway provided an ideal training ground for novice gunners. Using a fast motorboat, or "sea sled," gunnery students sharpened their skills by firing a Lewis machine gun at targets in Lake St. Clair.

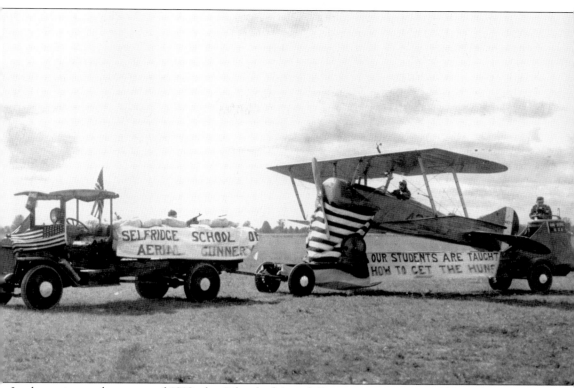

In the spring and summer of 1918, the School of Aerial Gunnery was training 250 students at a time. Washington soon discovered the value to the war effort of trained aerial gunners and began to draw extensively upon the school. The base proudly proclaimed the prowess of its gunners, as seen in this photograph, believed to depict a parade unit in one of the local Liberty Bond drive efforts.

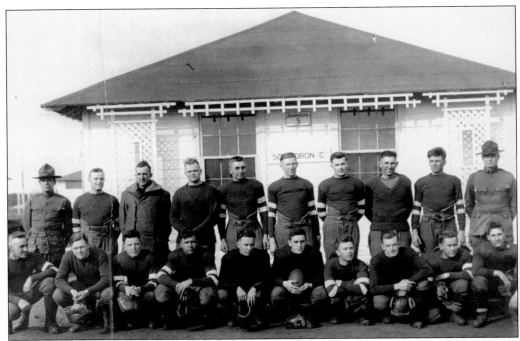

Despite the war raging in Europe and the breakneck pace at which operations were being ramped up at the field during its inaugural year, the post's personnel still found time for recreation. Basketball and football games were especially competitive. Here, the football team of Squadron C poses in front of the barracks.

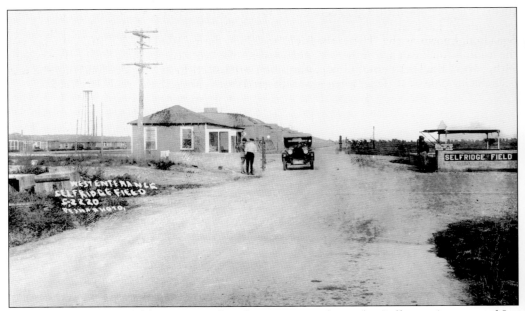

Visitors to the new airfield were greeted at this sentry post located at Jefferson Avenue and Joy Boulevard. Mount Clemens residents were cautioned by the local newspaper not to ask a lot of questions about what was going on at the field. (Courtesy of Hank and Phyllis Miller.)

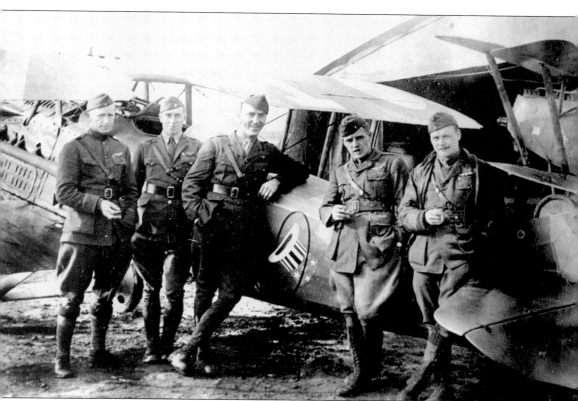

Lt. Joseph H. Eastman, Capt. James A. Meissner (1896–1936), Capt. Eddie V. Rickenbacker (1890–1973), Lt. Reed M. Chambers (1894–1972), and Lt. Thorne C. Taylor (pictured from left to right) stand in front of one of the SPAD XXII.C.1 aircraft flown by the 94th Pursuit Squadron, known as the "Hat-in-the-Ring" squadron, during World War I. Rickenbacker was the leading American ace of the war, with 26 confirmed air victories to his credit. The valiant 94th, part of the First Pursuit Group, was headquartered briefly at Selfridge following the war, before being ordered to Texas when it was rumored that Selfridge Field would be closed.

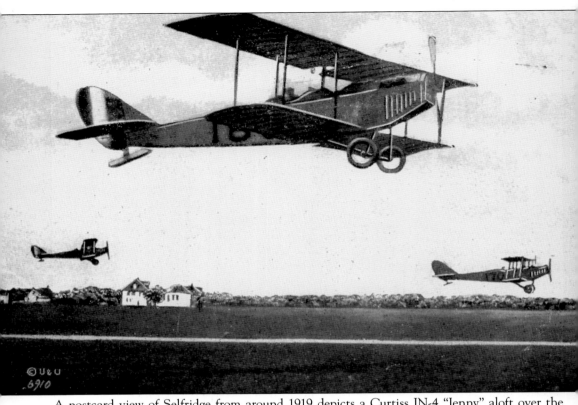

A postcard view of Selfridge from around 1919 depicts a Curtiss JN-4 "Jenny" aloft over the field. The Jenny served as the primary trainer of the air service during this time period and was flown by elements of the First Pursuit Group from 1919 to 1924.

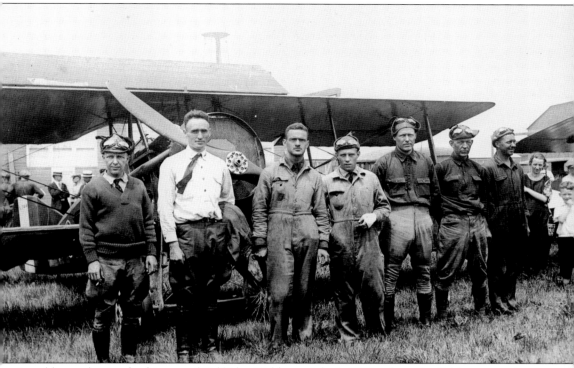

A red-letter day in the history of Selfridge Field was July 1, 1922, when the field once again became home of the First Pursuit Group, which had been headquartered there briefly at the close of World War I. Commanded by then-Maj. Carl Spaatz (1891–1974), the personnel and aircraft made a historic flight in SE-5s, SPADs, and De Havillands from Ellington Field, Texas, to their new home at Selfridge Field. Shown here from left to right are Lt. Roy B. Mosher (1890–1958), Lt. Hobart R. Yeager (1895–1985), Capt. Frank O'D Hunter (1894–1982), Lt. George P. Tourtellott (1896–1946), Capt. George C. Tinsley (1895–1922), Sergeant Newcombe, and Sergeant Anderson. Five days after this photograph was taken, Captain Tinsley was killed in the crash of a SPAD near Selfridge Field.

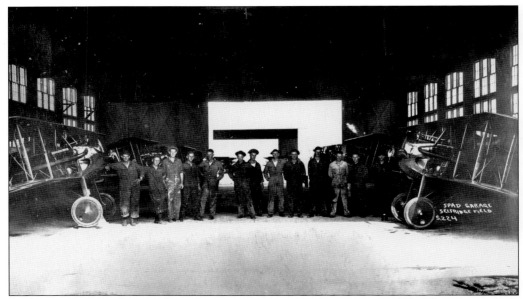

Mechanics pose with aircraft under repair in the SPAD garage in 1922. The French-built biplanes were discarded in October of the same year in favor of the new Thomas-Morse/Boeing MB-3A pursuit craft.

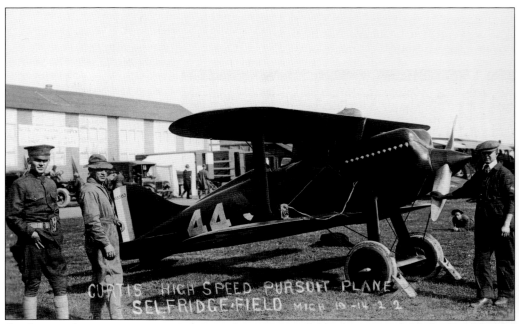

As if to emphasize its growing stature in the emerging field of aviation, Selfridge Field hosted the National Air Races in October 1922. Events included the Pulitzer Trophy race, in which the victorious Lt. Russell L. Maughan (1893–1958) set a new world speed record in a Curtiss Model 23 Army R-6 Racer, shown here on the day of the race. (Courtesy of Hank and Phyllis Miller.)

The emblem of the First Pursuit Group was authorized on January 21, 1924. The five stripes signify the original five flying squadrons of the group, and the five crosses symbolize the five major campaigns of World War I credited to the group. A crest above the shield carried the motto *Aut Vincere aut Mori*, which translates as "conquer or die."

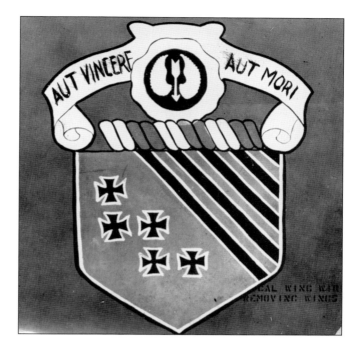

A falcon about to strike, shown against a red disc, was approved as the insignia of the 27th Pursuit Squadron of the First Pursuit Group in 1924.

The great snow owl was approved as the insignia of the First Pursuit's 17th Pursuit Squadron in 1924, appropriate for a unit based in the wintry north.

Authorized on September 6, 1924, the American Indian head symbol, formerly used by the 103rd Aero Squadron, became the official insignia of the 94th Pursuit Squadron. It replaced the squadron's Hat-in-the-Ring symbol, which was deemed inappropriate as it was being used by a commercial enterprise, the Rickenbacker Automobile Company.

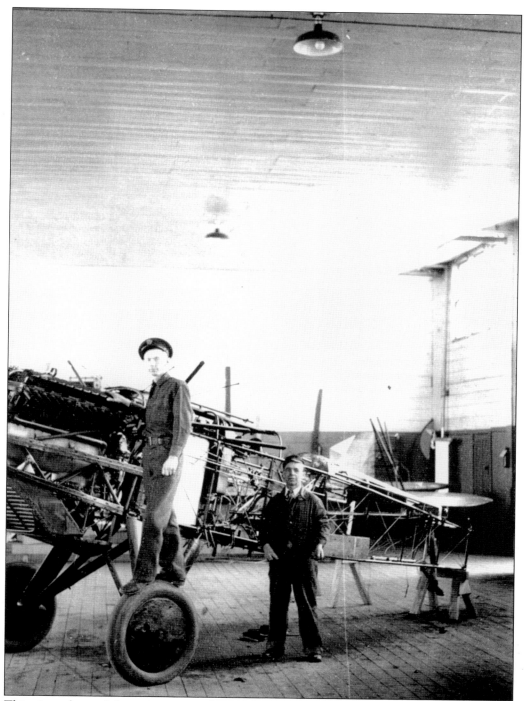

This view of one of the maintenance shops, taken around 1924, shows two men examining one of the airplanes. In addition to knowledge of engine repair, early aviation mechanics needed skills in working with wood and fabric, the primary materials from which the aircraft wings and fuselage were fabricated.

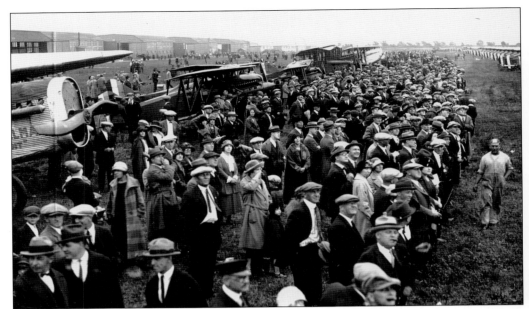

Selfridge hosted an air show on September 14, 1924, before a crowd of 15,000 spectators. Among the events of the day were airplane rides offered by lottery to civilians. The local newspaper reported that a woman incensed at her exclusion from the flights attempted an appeal to air service officials in Washington, D.C., but was informed that official orders specified that "women shall not fly in government airplanes."

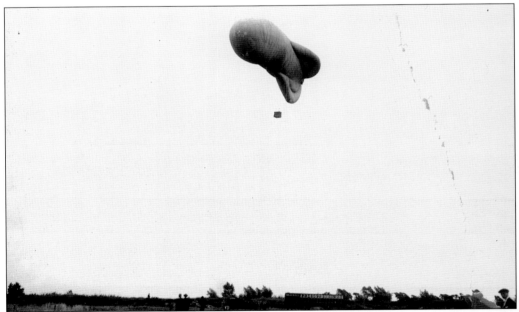

A crowd-pleasing highlight of the air show was an attack on this "sausage balloon," used for observation purposes in wartime. Pursuit craft armed with .30- and .50-caliber machine guns strafed the balloon and caused it to burst into flames, to the delight of the assembled onlookers.

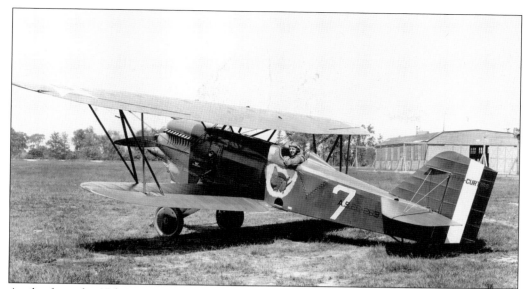

A pilot from the 27th Pursuit Squadron poses with his Curtiss P-1A "Hawk." The Curtiss Hawks were the first series of pursuit craft for which the army used the single "P" prefix, consolidating the seven different pursuit designations used previously. This model went into service with the army air corps in April 1926.

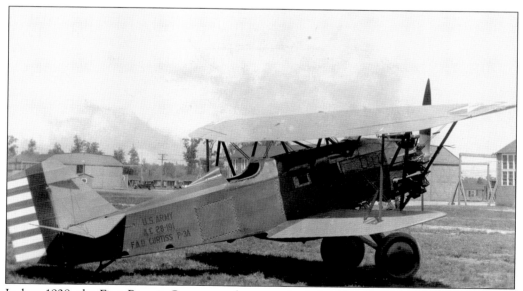

In late 1928, the First Pursuit Group squadrons received the Curtiss P-3A, the first attempt to adapt the Curtiss P-1 airframe to power by radial engine. The airplane shown here was one of five ordered by the army on an experimental basis and tested by Selfridge squadrons. (Courtesy of Fred Prahl.)

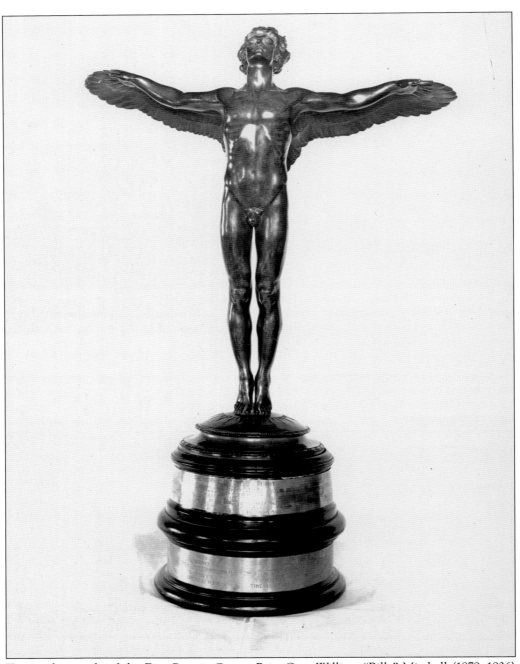

To test the mettle of the First Pursuit Group, Brig. Gen. William "Billy" Mitchell (1879–1936) created the Mitchell Trophy Race in 1922. General Mitchell donated the John L. Mitchell Trophy in memory of his brother, who had been a member of the First Pursuit Group at the time of his death during World War I. The contest consisted of five laps flown over a 20-mile closed course, and the participating pilots set multiple aviation speed records over the 14 years in which the air race was conducted. (Courtesy of Clarke Historical Library, Central Michigan University.)

Lt. Cyrus K. Bettis (1893–1926) was the winner of the 1924 Mitchell Trophy Race, held at Wright Field near Dayton, Ohio, with an average speed of 175.43 miles per hour. Bettis also won the Pulitzer Trophy the following year and was subsequently killed in an airplane crash in Pennsylvania in 1926. He was one of six unfortunate Mitchell Trophy winners who perished in air crashes.

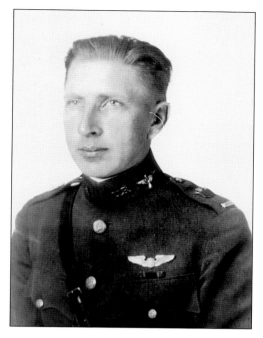

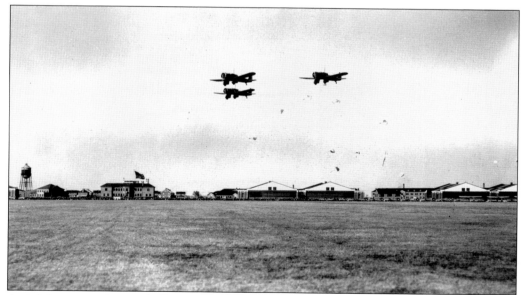

Aerial demonstrations with Curtiss A-12 "Shrikes" are shown underway over Selfridge Field on the day of the 1934 Mitchell Trophy Race. The Mitchell contest was won by Capt. Fred C. Nelson in a Boeing P-26A "Peashooter," with a record-breaking speed of 216.832 miles per hour.

Mitchell Trophy pilots enrolled in the 1935 race pose with their Boeing P-26A Peashooter. The participants included Maj. Edwin House, Lt. Jarred V. Crabb (1902–1981), Capt. Earle E. Partridge (1900–1990), Capt. Lee Q. Wasser (1901–1955), Capt. Paul M. Jacobs, Capt. Dixon M. Allison, Capt. Norman P. Frost, Capt. Daniel C. Doubleday (1905–2001), Capt. Walter E. Todd (1906–1978), and Capt. Karl E. Gimmler.

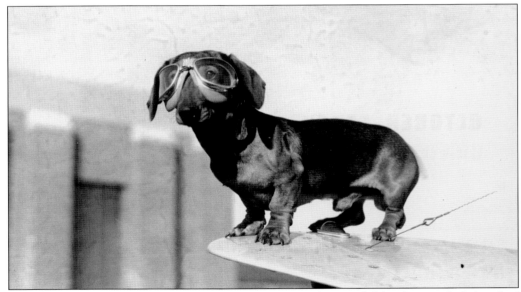

Some air racing participants were more daring than others. Adolph, the pet dachshund of 1st Lt. Rudolph Fink, poses for the camera during the 1936 Mitchell Trophy race. Adolph and Lt. Fink often flew together, and the intrepid dachshund recorded more than 100 hours in his log book.

MITCHELL TROPHY AIR RACES

SELFRIDGE FIELD
MOUNT CLEMENS
MICHIGAN

OCTOBER SEVENTEENTH
NINETEEN HUNDRED THIRTY
SIX

BENEFIT
U. S. ARMY RELIEF
MOUNT CLEMENS
COMMUNITY
FUND

SOUVENIR PROGRAM TWENTY FIVE CENTS

The final Mitchell Trophy race was flown at Selfridge in 1936, when Lt. John M. Sterling (1904–1976) posted a 217-mile-per-hour win. A race was scheduled for 1937 but was canceled due to lack of available airplanes—a situation that grew worse as another war approached. Perhaps the race's demise resulted from the rapid advances in aviation technology; only 11 years after Sterling's 1936 win, the sound barrier would be broken and the aviation world would begin to measure speed records in Mach numbers.

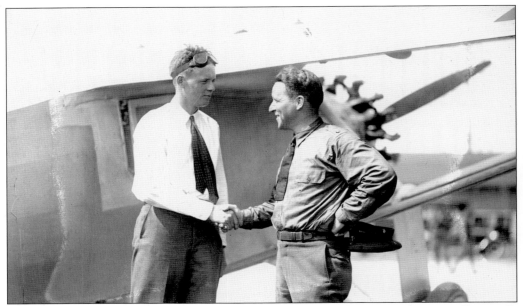

Selfridge celebrated an aviation milestone of another kind on July 1, 1927, when Maj. Thomas G. Lanphier (1890–1972) welcomed Charles A. Lindbergh (1902–1974) to the field with his Ryan monoplane, the *Spirit of St. Louis*. Only weeks before, Lindbergh had completed his historic transatlantic flight. No stranger to Selfridge Field, Lindbergh had served at the base in 1924. (Courtesy of Walter P. Reuther Library, Wayne State University.)

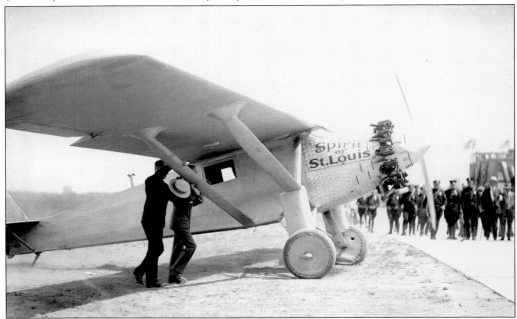

The *Spirit of St. Louis* garnered considerable interest as it sat on the flight line at Selfridge. Lindbergh gave his friend, Major Lanphier, the honor of piloting the *Spirit* on a local flight in the vicinity before he departed Selfridge for a celebration in Ottawa, Ontario. (Courtesy of Walter P. Reuther Library, Wayne State University.)

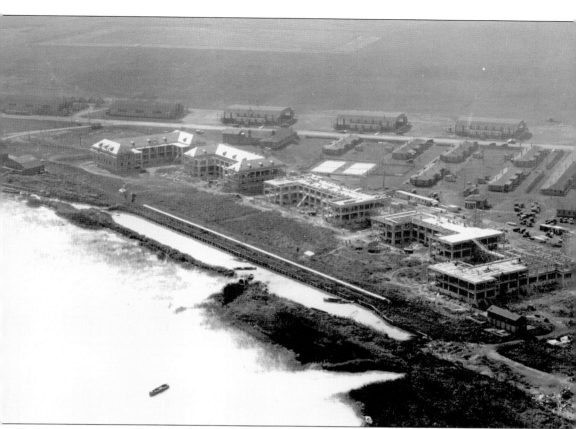

After the government completed the outright purchase of the Selfridge property in 1922, the base became a permanent military installation and was transformed by a building boom. This 1927 view shows new buildings under construction, with masonry structures replacing the wooden ones hastily erected in 1917. The hangar line is visible along the top third of the frame.

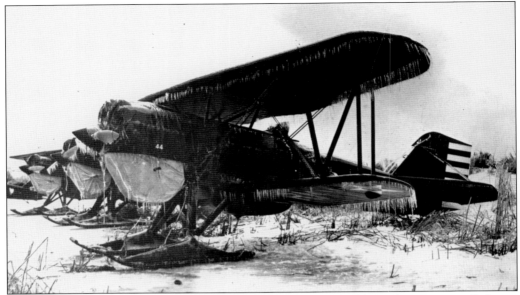

On January 7, 1930, the First Pursuit Group prepared to depart Selfridge for winter test flights in Spokane, Washington, by pushing their Curtiss P-1 airplanes, equipped with skis, onto the ice of Lake St. Clair. Overnight, a severe sleet storm struck and covered the airplanes with a thick coating of ice, delaying the departure for another day.

Curtiss Hawks are shown along the flight line in 1930. The squadrons of the First Pursuit Group flew various models of the Hawk from 1925 to 1938.

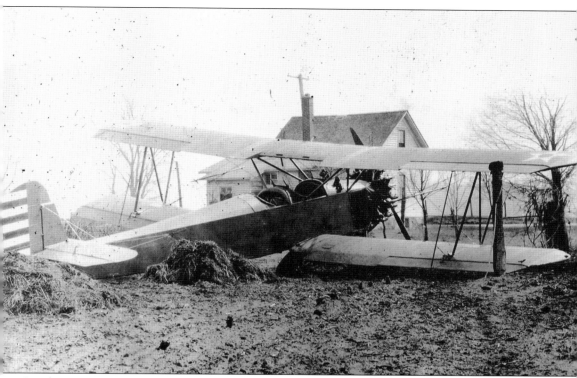

Accidents were not uncommon during the pursuit era at Selfridge Field. Not only was Selfridge very busy as the army's only active pursuit field during the interwar years, but it was also handling the operational readiness testing for many types of aircraft. On March 28, 1931, then-2nd Lt. Curtis E. LeMay (1906–1990) of the 27th Pursuit Squadron made this forced landing in his Consolidated PT-3A primary trainer. Crashing six miles north of the airfield, he escaped injury and went on to a stellar career in military aviation, retiring at the rank of general after having served as air force chief of staff. (Courtesy of Clarke Historical Library, Central Michigan University.)

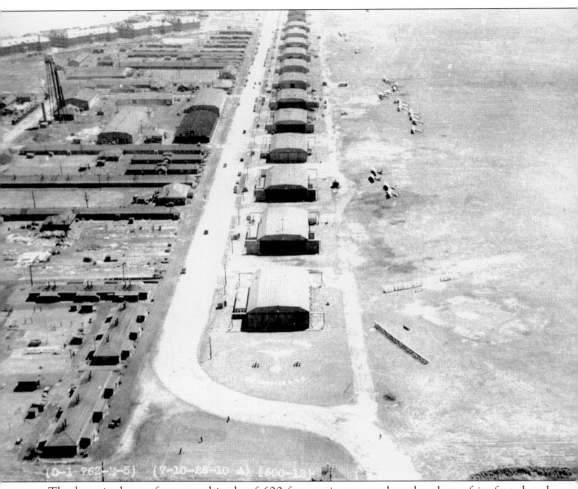

The base is shown from an altitude of 600 feet, as it appeared at the close of its first decade, looking eastward from the main gate at Joy Boulevard and Jefferson Avenue. At the foot of the hangar line is an emblem of the First Pursuit Group; numerous aircraft are apparent along the flight line in front of the hangars. Paved runways had not yet been installed, and aircraft took off and landed on turf.

Three

EXPANSION
AND WORLD WAR

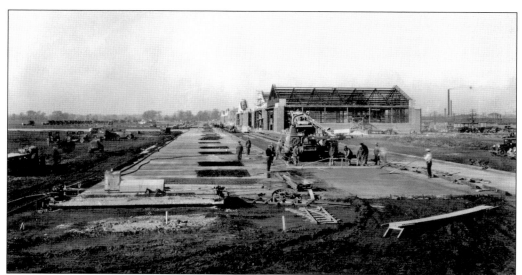

In March 1931, $500,000 was appropriated for new building and infrastructure improvements at Selfridge Field. More of the wooden structures erected in 1917 were replaced with brick and mortar. This view looking westward along the flight line shows new hangars in frame and ramp paving underway. Paved runways were first laid during this building boom.

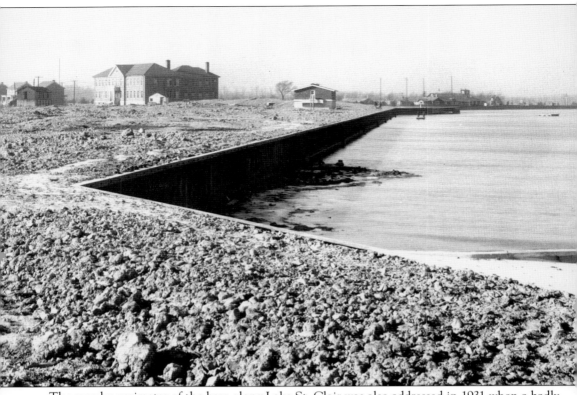

The marshy perimeter of the base along Lake St. Clair was also addressed in 1931 when a badly needed seawall was engineered. Approximately 300,000 cubic yards of backfill dredged from Anchor Bay created solid ground on which officer housing could be erected. This view shows the fill behind the seawall, looking westward toward the hospital.

This is how the Post Exchange (PX) at George Avenue and Wilbur Wright Boulevard appeared in 1931. As all military posts had done since 1895, Selfridge Field operated this store to sell personal items and general merchandise to soldiers stationed at the base.

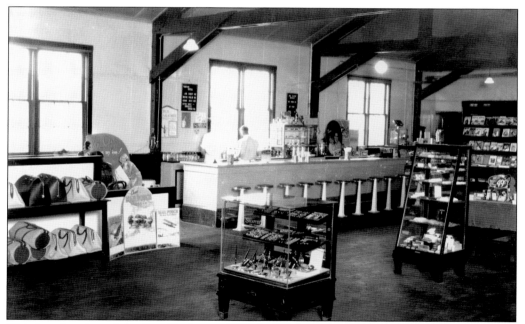

This interior view of the Post Exchange (PX) shows a soda fountain in the center background, where a hungry soldier could enjoy a banana split for 25¢.

Newly paved George Avenue is shown looking eastward from the 300 block in 1931. George Avenue was named to honor the memory of Brig. Gen. Harold H. George (1892–1942), a World War I fighter ace who served at Selfridge during the late 1930s and lost his life in an airplane accident during World War II.

Building 50, the Base Flight Operations center, is shown under construction on August 31, 1931. A month earlier, Capt. Bartholomew Parks had been making a landing in his Douglas O-2H observation biplane, when ironically, he failed to see the construction tower on the roof of the new building and struck it, crashing his ship onto the airfield, but escaping with only minor injuries.

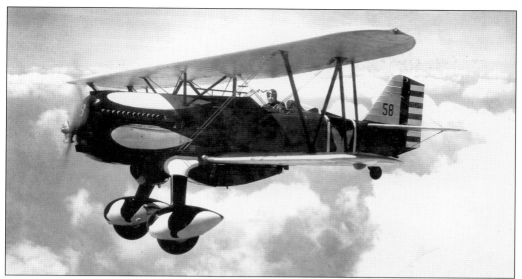

Capt. Ross G. Hoyt (1893–1983) of the 17th Pursuit Squadron is shown at the controls of a Curtiss P-6E Hawk in 1932. The P-6E was the last biplane pursuit craft built in quantity for the air corps. These airplanes sported a distinctive paint scheme featuring fierce talons on the wheel fairings. (Courtesy of Clarke Historical Library, Central Michigan University.)

Maj. Ralph Royce (1890–1965) poses in front of a Martin B-10 bomber while serving as operations officer for a historic flight of B-10s from Washington, D.C., to Fairbanks, Alaska, in 1934. Major Royce served as commander of the First Pursuit Group at Selfridge from 1934 to 1937. (Courtesy of Clarke Historical Library, Central Michigan University.)

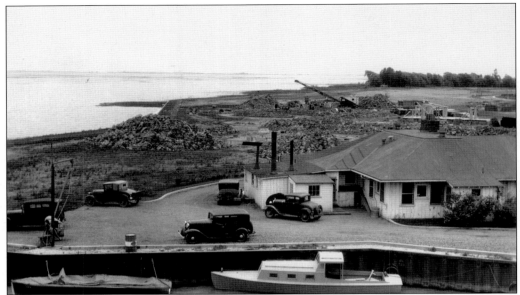

In 1934, construction began on permanent, two-story officer residences along Lake St. Clair. The frame house visible in the foreground is the original base commander's quarters and boat slip. The commander's house was situated on a small island along the lake shore and was later joined to the main base property with landfill. A new commander's residence was completed in 1935 and this structure was razed.

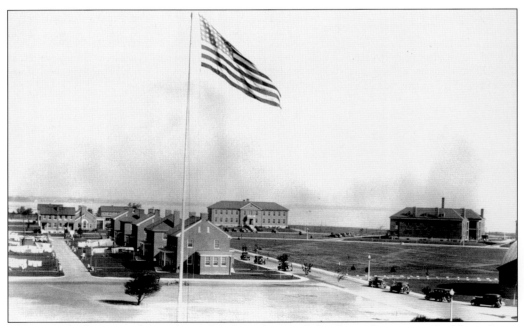

The view looking northeast from the front lawn of the Base Operations building shows permanent family housing in place in 1934. Apparently, this photograph was taken on wash day, as laundry is seen on the line outside many of the residences.

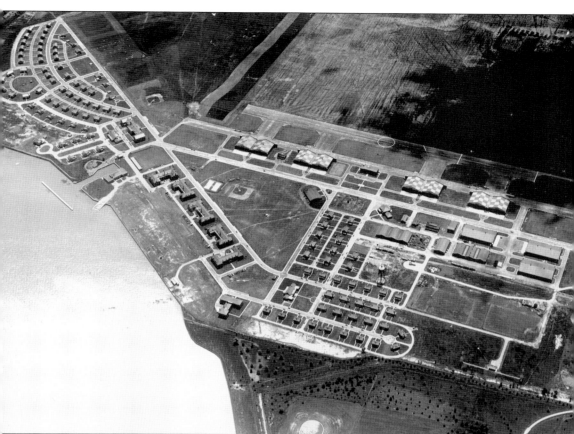

A 1935 aerial view of Selfridge Field shows the construction progress. Visible in the upper left is the 400 housing area, including two-story officer residences. Permanent hangars are seen along the upper third of the frame.

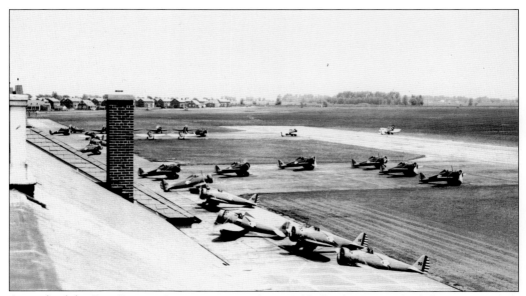

Aircraft of the First Pursuit Group prepare to leave Selfridge for Camp Skeel (later Wurtsmith Air Force Base) near Oscoda, Michigan, in 1936. Using Camp Skeel as their base, the squadrons flew training exercises in Michigan and Indiana. Training of this type was also conducted at Kent County Airport near Grand Rapids.

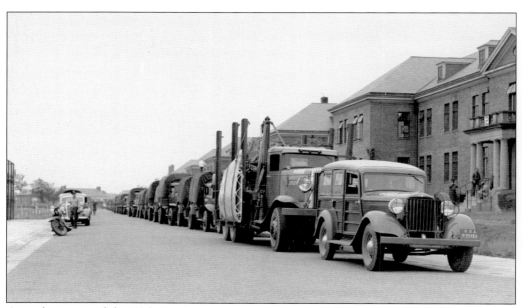

A truck convoy of the 56th Services Squadron returns to Selfridge Field from Camp Skeel on May 20, 1936, at the conclusion of training exercises. Notice the aircraft wing lashed to the side of the truck.

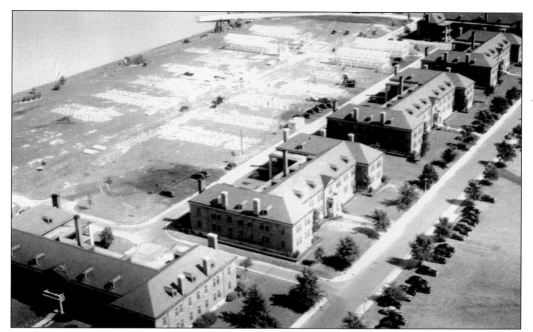

At the same time that war was erupting again in Europe, Selfridge Field was tasked with the mission of training four new pursuit groups. To accommodate the influx of additional personnel, a $13 million construction program was launched. In September 1939, a double row of temporary barracks began to rise behind the 300 block of permanent housing.

SHOW TIMES
NGS
6 & 8 PM.
YS
-6:30 & 8:30 PM.

F--FAMILY AUD
M--MATURE AU

WAR DEPARTMENT THEATRE
SELFRIDGE FIELD MT. CLEMENS MICHIGAN
POST DISTRIBUTION ONLY

APRIL 1938

SUNDAY	MONDAY	TUESDAY		THURSDAY	FRIDAY	SATUR
AY SCHOOL 9:30 AM CLUB					F A GIRL WITH IDEAS WENDIE BARRIE WALTER PIDGEON	THE DEVIL'S S DICK FORAN ANNE NAC
LIC SERVICE RE 9:30 A.M.					I UNUSUAL OCCUPATIONS A RENTED RIOT OSWALD CARTOON	2 DICK TRACY KEN MURRA SCRAPPY CA
H SERVICE TRE 10:45 A.M.						
F BUCCANEER DERIC MARCH RGOT GRAHAME 3	F TRAIL OF THE L'NESME PINE FRED MAC MURRAY SYLVIA SYDNEY 4	M BARONESS & THE BUTLER WILLIAM POWELL ANNABELLA 5	6	M EVERY DAY'S A HOLIDAY MAE WEST EDMUND LOWE 7	DAUGHTER OF SHANGHAI ANNA MAY WONG CHARLES BICKFORD 8	TEXAS TR WM. BOYD GEO HAY 9
SHOW 8:45 NEWS	STRNGR TH ION TERRYTOO	SONG HIT STORY UNIVERSAL NEWS		COLOR CLASSIC EDGAR BERGEN FOX NEWS	WILLIE HOWARD SPORTLIGHT BETTY BOOP	DICK TRAC POPEYE MELODY MA
ABOUT MUSIC NA DURBIN RBERT MARSHALL 10	GALE OF THE WILD LORETTA YOUNG CLARK GABLE 11	TARZAN REVENGE GLENN MORRIS ELEANOR HOLM 12	13	OF HUMAN HEARTS WALTER HUSTON GUY KIBEE 14	CHARLIE CHAN AT MONTE CARLO--WARNER OLAND KEYE LUKE 15	SEZ O'RIELLY WILL FYFFE WILL MAHO 16
ZENJAMER KIDS NEWS	GOING PLACES MERRY MELODY	MARCH OF TIME COLORTOUR ADVTRE UNIVERSAL NEWS		FOX NEWS	CUPID TAKES A HOLIDAY TREASURE CHEST LOONEYTUNE	DICK TRA OSWALD C
AN OF BRIMSTONE LACE BEERY RGINIA BRUCE 17	MR DEEDS GOES TO TOWN GARY COOPER JEAN ARTHUR 18	SOMETHING TO SING ABOUT JAMES CAGNEY EVELYN DAW 19	20	SALLY IRENE & MARY ALICE FAYE FRED ALLEN 21	MURDER ON DIAMOND ROW EDMUND LOWE SEBASTIAN SHAW 22	RENFREW OF JIMMY NE CAROL 2
PY HARMONY NEWS	2ND SHOW 8:15 NU-ATLAS MUSICAL	PICTORIAL REVIEW UNIVERSAL NEWS		POPULAR SCIENCE FOX NEWS	JEFFERSON MESCHAMER OUR GANG COMEDY	DICK TRAC CRIME DOES PATH SPO
EARD'S 8 TH WIFE Y COOPER AUDETTE COLBERT 24	M BROADWAY BILL WARNER BAXTER MYRNA LOY 25	M RADIO CITY REVELS BOB BURNS JACK OAKIE 26	27	A YANK AT OXFORD ROBT. TAYLOR LIONEL BARRYMORE 28	PENROD AND HIS TWIN MAUCH TWINS SPRING BYINGTON 29	LAW FOR TO BUCK JON MURIEL E 30
EYE	TRAVELTALK	SONG HIT STORY		FOX NEWS	B WEST & T PATRICOLA FLOYD GIBBONS NEW SPORT THRILLS	DICK TRAC TERRYTOO SMART SET

The expansion of Selfridge Field afforded the opportunity to offer more recreational venues to the personnel, including a movie theater. This 1938 schedule from the Base Theater features popular Hollywood releases of the day, including *Call of the Wild*, *Trail of the Lonesome Pine*, and *Mr. Deeds Goes to Town*.

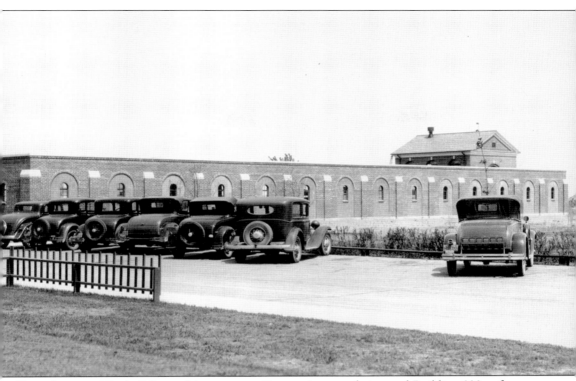

One of many utility buildings, this garage on George Avenue, designated Building 330, reflects the same architectural style that distinguishes most of the structures erected on the base during the 1927–1934 era.

The Main Gate building at Jefferson Avenue and Joy Boulevard is shown during construction and after completion in 1934. This first "permanent" entryway to the base shared the Georgian revival architecture of most of the new structures erected during this time period. Only eight years later, the Main Gate would move to the intersection of Jefferson Avenue and Rosso Highway, as the wartime expansion of the base added property northward and westward.

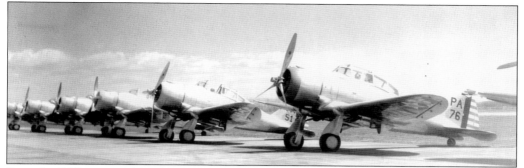

Seversky P-35s, received by the First Pursuit Group's squadrons in late 1937, are shown on the flight line. The P-35 was the first single-seat, all-metal pursuit craft with retractable landing gear to be used in regular service with the air corps, but it grew obsolete quickly and was replaced by the P-39 "Aircobra" and P-40 "Warhawk" by 1941.

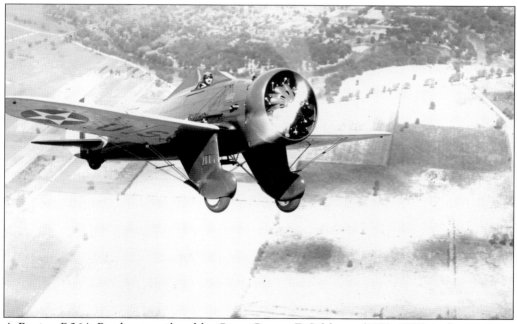

A Boeing P-26A Peashooter piloted by Capt. George F. Schlatter (1903–1979) is shown above Selfridge Field during a 1939 flight. Captain Schlatter was a member of the 17th Pursuit Squadron and served as the air corps chief of pilot training at the beginning of World War II, rising to the rank of brigadier general in the U.S. Air Force.

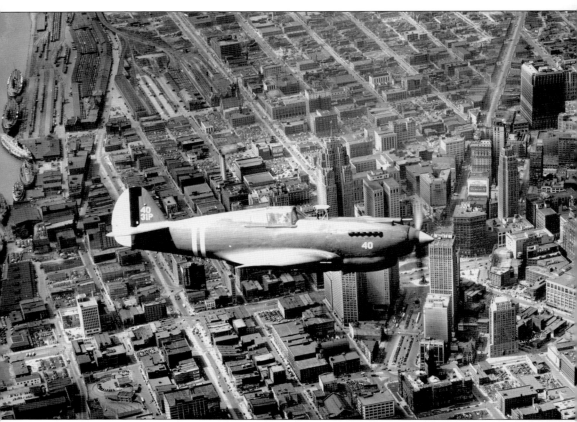

A Curtiss P-40 Warhawk takes flight over Detroit. The P-40 went into production in 1939 and served Allied forces until the end of World War II. Claire Chennault's volunteer group, known as the "Flying Tigers," flew P-40s decorated with a menacing paint scheme. Squadrons at Selfridge received their P-40s in 1940 and flew them off to war the following year.

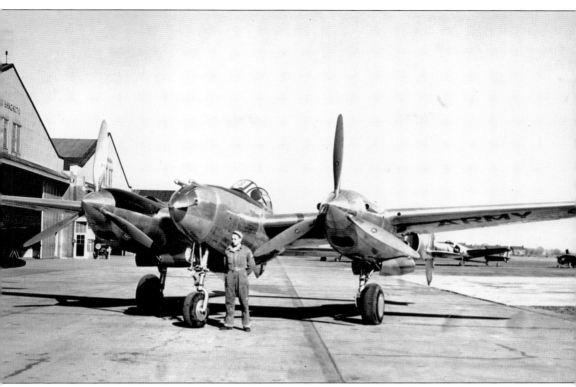

A Lockheed P-38 "Lightning" high-altitude interceptor is shown on the flight line in front of Hangar 7. The P-38 was the first military aircraft built by Lockheed and was the fastest American fighter at the time that the 94th Pursuit Squadron received the first models at Selfridge in 1941. Maj. Richard I. Bong (1920–1945), the highest-scoring American ace of World War II, achieved his 40 aerial victories in a P-38.

As the flames of war intensified in Europe, training became a growing mission at Selfridge Field, as this September 1941 photograph of morning inspection shows. Immediately after the Pearl Harbor attack, the First Pursuit Group's flying squadrons were ordered to California, and Selfridge switched to full-time instruction of raw recruits, providing basic training and assigning personnel to newly formed units.

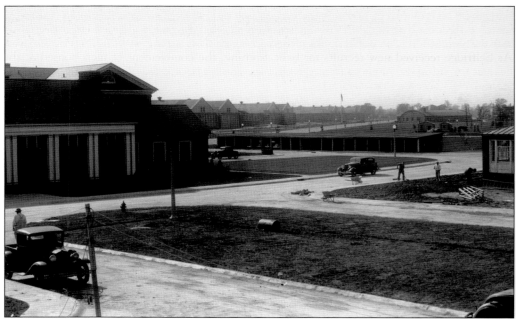

Building 400, the Officers Club, is shown at left in a view looking west from Lufbery Circle in 1934. The north-south garage is seen in the center background, and the Post Exchange (PX) is visible in the far right background. The Officers Club was destroyed by fire in August 2000.

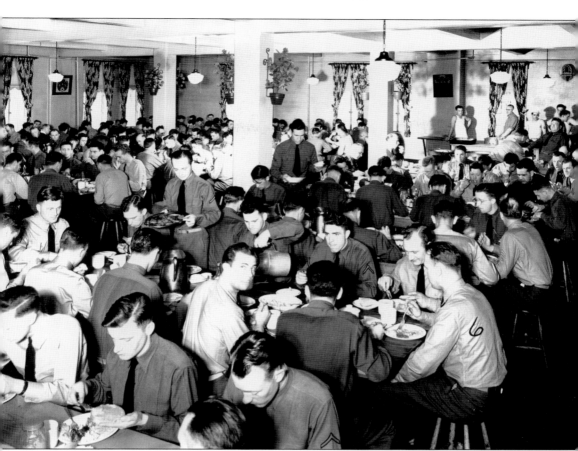

As Selfridge received new recruits for basic training, the complement of men housed at the field far surpassed the numbers from the interwar years. The enlisted dining room, shown here around 1942, became a crowded place.

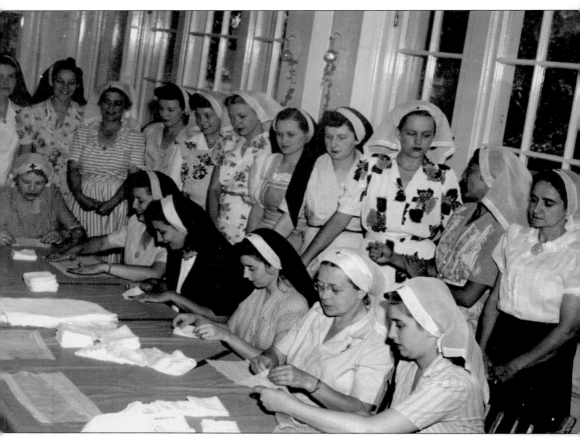

During World War II, more than 7 million Americans volunteered for the Red Cross, providing a variety of services, including the rolling of billions of bandages. Like bases and communities across the nation, Selfridge Field had no shortage of willing hands. These women are shown rolling bandages during the closing days of the war.

Selfridge Field received its first true air traffic control tower when this 65-foot structure opened in April 1943. Until that time, controllers worked in a small tower atop the Base Operations building, which was manned only during daytime hours. After the outbreak of World War II, 24-hour operations commenced, and the need for a new facility was addressed as part of the wartime base expansion.

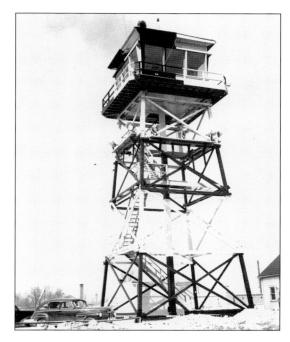

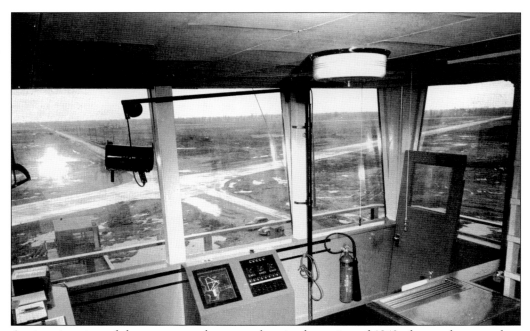

An interior view of the new control tower, taken in the spring of 1943, shows what was then state-of-the-art air traffic control equipment. Looking northwest through the tower windows, Joy Boulevard runs east and west and a taxi strip can be seen running north and south. This tower was used until 2002.

An evacuation drill is shown underway in 1942 outside Building 150. Originally a restaurant known as the Selfridge Tavern, it was located just outside the gate and became part of the base when the government condemned surrounding property to increase the size of the installation from 641 to more than 3,000 acres. The structure later served as a squadron operations building, fuels lab, and recreational facility.

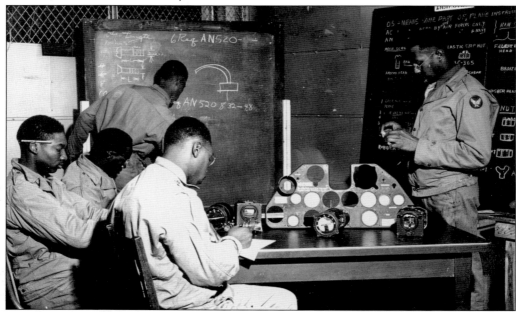

In the spring of 1943, elements of the 332nd Fighter Group, known as the Tuskegee Airmen, came to Selfridge Field for advanced training. This famous organization of African American aviators and support personnel was highly decorated for its unparalleled combat success in World War II. In this view, members of the Group's 302nd Fighter Squadron learn about aircraft instruments and their operation.

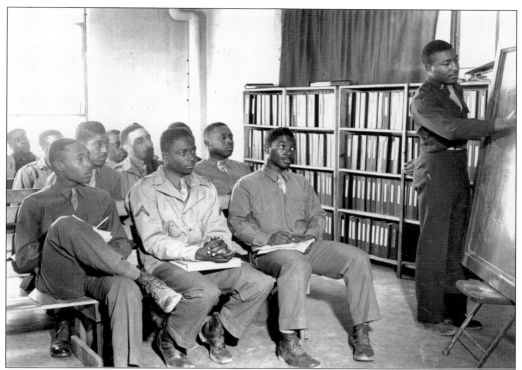

Members of the 302nd Fighter Squadron, one of four squadrons that made up the 332nd Fighter Group, are shown attending one of the maintenance schools at Selfridge Field. Their education included classroom instruction and hands-on experience with the Pratt and Whitney radial engine.

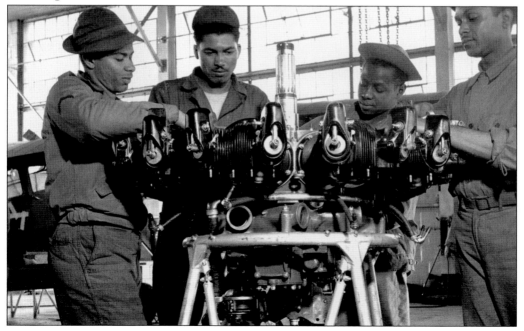

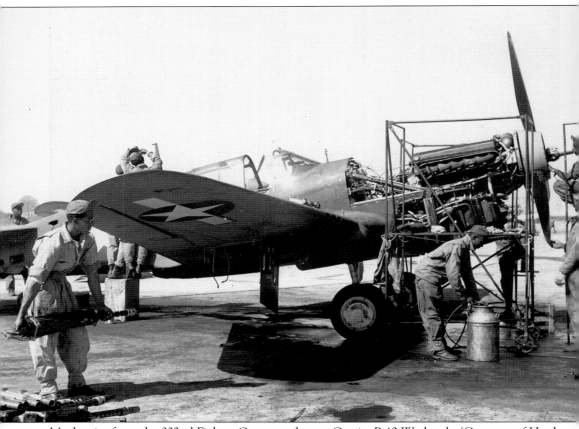

Mechanics from the 332nd Fighter Group work on a Curtiss P-40 Warhawk. (Courtesy of Hank and Phyllis Miller.)

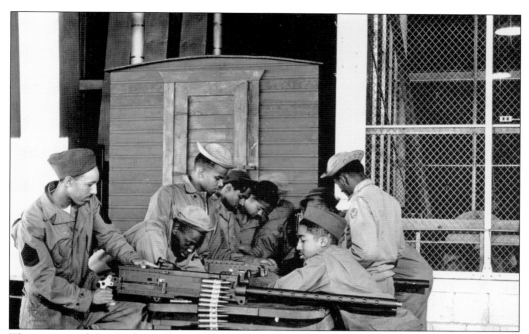

The success of the Tuskegee Airmen led to President Truman's 1948 executive order directing equality of treatment and opportunity in the U.S. Armed Forces. However, during their time at Selfridge, the units of the 332nd Fighter Group trained separately, as the Tuskegee effort was considered "experimental." In this view, a class on aircraft armament is underway.

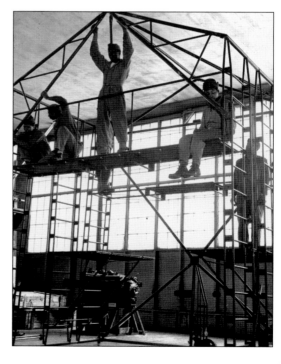

During wartime, Allied forces developed the ability to build instant runways and portable hangars to establish airfields in recently conquered territory. The hangars were designed to be erected quickly by just a few men equipped with basic tools. In this view, a trainee ground crew from the 302nd Fighter Squadron practices the assembly of a portable hangar inside one of Selfridge Field's permanent ones.

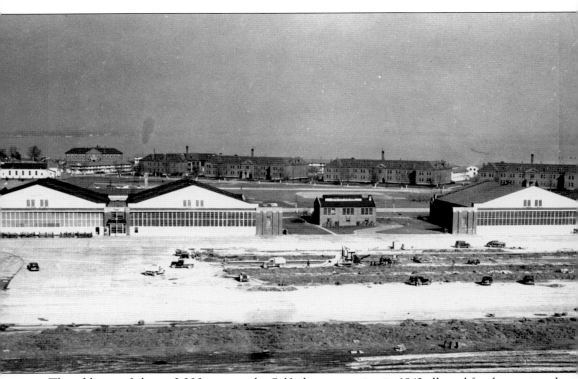

The addition of almost 3,000 acres to the Selfridge reservation in 1942 allowed for the westward expansion of the flying field, including an enlarged hangar line, ramp area, taxiways, and runways. This aerial view, looking north, shows cement being poured on the new parking area and hangar line. Anchor Bay can be seen in the background.

Four

THE JET
AND MISSILE AGE

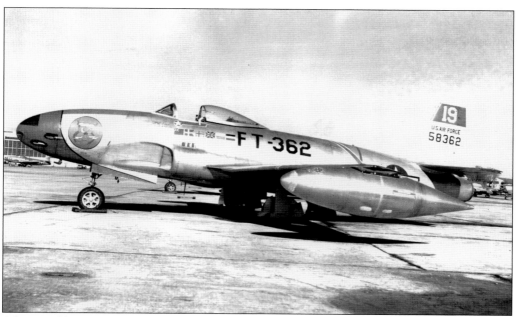

After World War II, Selfridge Field experienced a major transformation. In 1946, it became the new home of the 56th Fighter Group, with its three famous squadrons. The following year, the base was renamed Selfridge Air Force Base after the U.S. Air Force became a separate branch of service. Finally, the jet age came to Selfridge in April 1947, when the Lockheed P-80/F-80 "Shooting Star" jet fighters, shown here, were delivered.

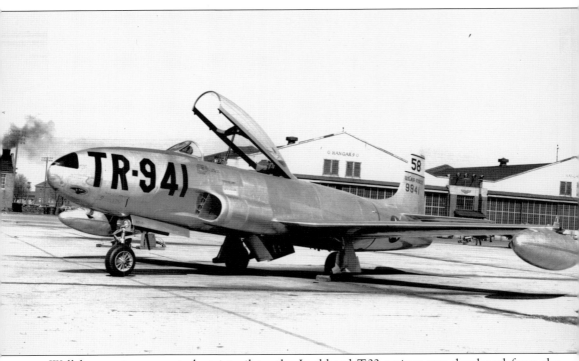

Well known to many student jet pilots, the Lockheed T-33 trainer was developed from the F-80 Shooting Star by lengthening the fuselage to accommodate a second seat. (Courtesy of William J. Balogh, via Menard.)

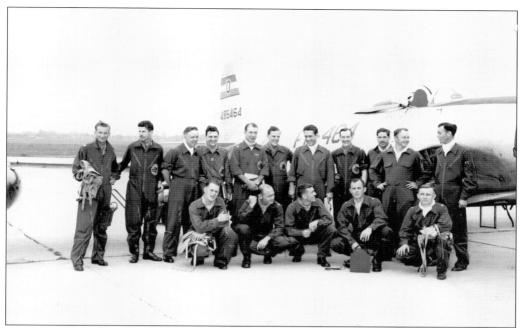

Selfridge units continued to make aviation history as they entered the jet age. The 56th Fighter Group took on a historic mission in July 1948, when 16 F-80 aircraft made the first west-to-east transatlantic crossing by jet aircraft. Participants in the milestone flight are shown here before departing from Selfridge. (Courtesy of *The Macomb Daily*.)

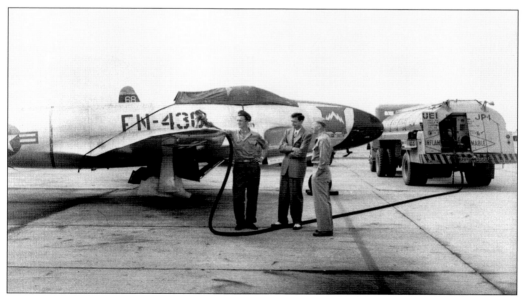

A Lockheed F-80 Shooting Star is fueled in preparation for Operation Fox Able One, the historic trip across the Atlantic that was intended to show the Soviet Union that rapid deployment from the United States was possible. *Daily Monitor-Leader* reporter Jack Kantner accompanied the flight to Europe and is seen observing at center. (Courtesy of *The Macomb Daily*.)

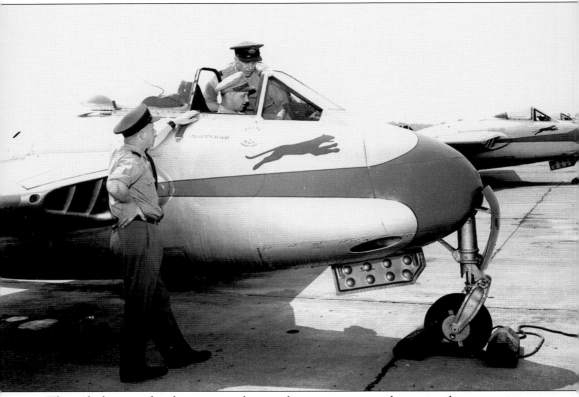

Through the years, local aviation enthusiasts became accustomed to seeing demonstration teams such as the Thunderbirds and the Blue Angels in the skies over Selfridge, but one of the first jet demonstration teams to visit the base was a Canadian unit. In 1949, the newly formed Blue Devils of the RCAF's 410th Fighter Squadron visited Selfridge with their British De Havilland "Vampire" jet fighters. (Courtesy of *The Macomb Daily*.)

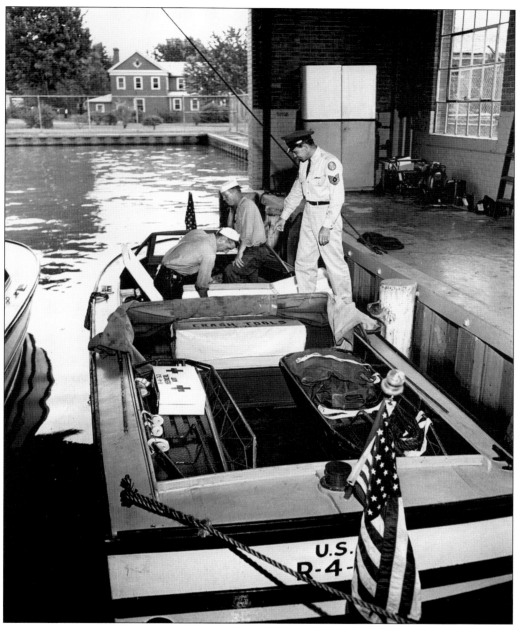

The location of the base on an international waterway made it necessary for the air force to maintain its own naval fleet, of sorts. The mission of the 332nd Crash Boat Flight was the rescue of personnel who were forced to "ditch," or bail out, over Lake St. Clair. Four rescue craft, including two 24-foot speed boats, one Higgins boat, and one 42-foot cabin cruiser were maintained at the ready. TSgt. George E. Balsey (standing) is shown supervising maintenance work by his crew, A2C Raymond McCann (left) and SSgt. John Falk (right). The crash boat flight also aided civilian boaters in trouble on the lake. (Courtesy of *The Macomb Daily*.)

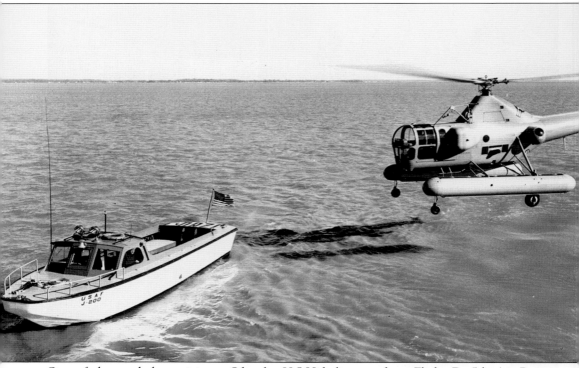

One of the crash boats joins a Sikorsky H-5-H helicopter from Flight D, 5th Air Rescue Squadron, in searching for some stranded boaters on Lake St. Clair in 1949. The two unhappy mariners were relieved to see their air force rescuers after spending 18 hours adrift. (Courtesy of *The Macomb Daily*.)

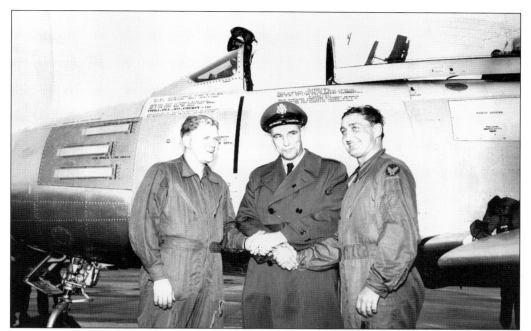

In 1950, Selfridge units began flying the North American F-86 "Sabre." Col. James R. Gunn Jr., base commander, welcomed Capt. Howard S. Askelton (left) and Lt. Col. Francis S. "Gabby" Gabreski (right) after they landed the first two Sabres on the airfield. An air ace in two wars, Gabreski (1919–2002) was commander of the 56th Fighter Group at Selfridge from 1949 to 1951. (Courtesy of *The Macomb Daily*.)

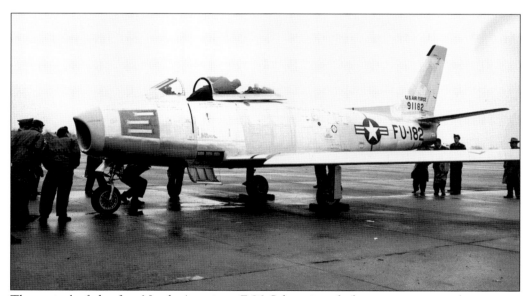

The arrival of the first North American F-86 Sabre aircraft drew attention on the ramp at Selfridge. One of the air force's most effective weapons during the Korean War, the F-86 maintained a 10-1 victory ratio against its Soviet-built counterpart, the MiG-15. (Courtesy of *The Macomb Daily*.)

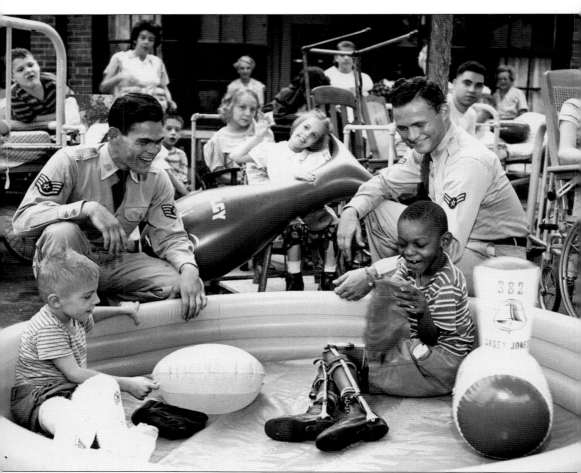

Personnel from Selfridge have always been ready and willing participants in community events for the benefit of children. During the 1950s, the nearby Sigma Gamma Hospital in Harrison Township was a favorite visiting spot for airmen. Sigma Gamma Hospital operated from 1925 to 1957 as a long-term treatment facility for children afflicted with polio and other orthopedic challenges. In 1951, SSgt. Lawrence Trammel (left) and Cpl. Jack Fleming (right) sponsored a dance to raise funds to purchase new play equipment for the hospital's young patients. (Courtesy of *The Macomb Daily.*)

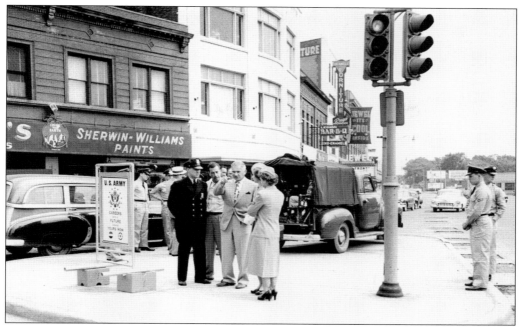

Cordial relations between Selfridge and the city of Mount Clemens were celebrated in 1951 when the air force commissioned a film featurette entitled *The Mount Clemens Story*. Filmed on the base and in Mount Clemens, the documentary featured both airmen and local citizens. Director Derwin M. Abrahams (1903–1974) and his crew are shown here setting up a scene on Gratiot Avenue. (Courtesy of *The Macomb Daily*.)

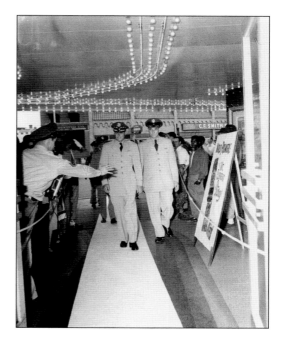

Chief of Staff Gen. Hoyt S. Vandenberg (1899–1954) of the air force and Base Commander Col. James R. Gunn Jr. enter the Jewel Theater in downtown Mount Clemens for the world premiere of *The Mount Clemens Story* on August 13, 1951. (Courtesy of *The Macomb Daily*.)

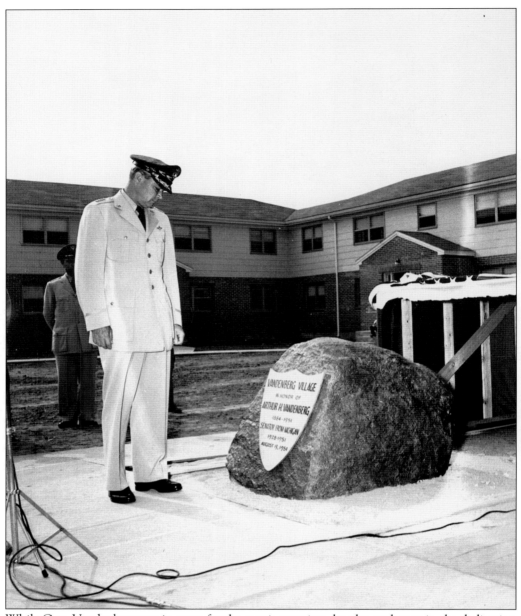

While Gen. Vandenberg was in town for the movie premiere, he also took part in the dedication of a new housing development at Selfridge. Named Vandenberg Village in honor of the general's uncle, Arthur H. Vandenberg (1884–1951), who had served 23 years as Michigan's senator, the new development provided 511 apartment units in 30 buildings. (Courtesy of *The Macomb Daily*.)

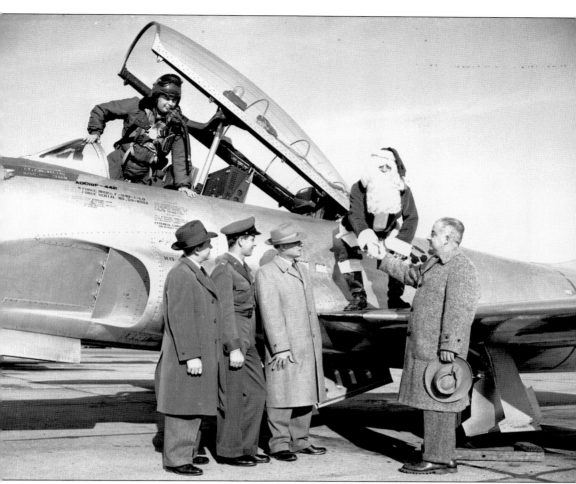

Year after year, Selfridge was instrumental in ensuring that Santa Claus arrived to greet the children of Mount Clemens in a timely manner. In 1951, Santa made the trip from the North Pole in a Lockheed F-94B Starfire, assigned to the 61st Fighter-Interceptor Squadron. Pilot Harry Crooks delivered the jolly elf to a warm reception from Mount Clemens Mayor Philip T. Mulligan (right), while Wendell Marzloff (left) and Floyd Eaton of the Board of Commerce, with Maj. Philip Adair, look on. (Courtesy of *The Macomb Daily*.)

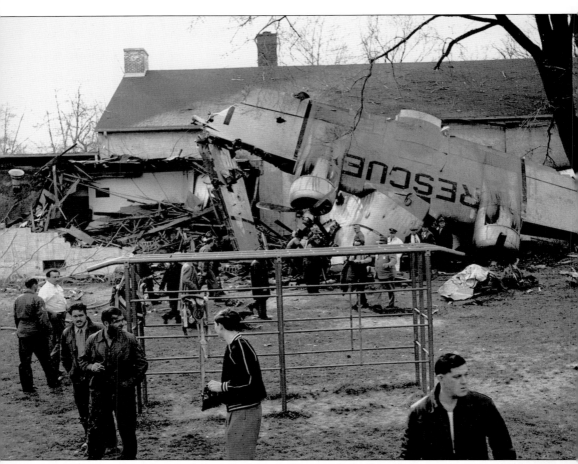

A 1951 aircraft mishap in downtown Mount Clemens looked much worse than it was. The crew of a Grumman SA-16 "Albatross," returning to Selfridge from a rescue mission in Tennessee, lost an engine upon approach to their home field and crashed atop the Mount Clemens Community Center on East Broadway. The pilot, Capt. Edwin L. Leonard, was credited with choosing a landing site for his disabled aircraft that would spare the most lives. Although the community center was partially destroyed, seven crew members aboard and all on the ground survived the accident without major injury. Seen in the foreground at left, holding a cigarette, is TSgt. Clarence G. Greenfield, flight engineer aboard the aircraft. (Courtesy of *The Macomb Daily*.)

Eight American jet aces visited Selfridge in 1952. From left to right are (first row) Capt. Richard S. Becker, Maj. James Jabara (1923–1966), Capt. Robert T. Latshaw Jr. (1925-–1956), and Capt. Iven C. Kincheloe Jr. (1923-1958); (second row) 1st Lt. Robert H. Moore, Maj. William T. Whisner Jr. (1923–1989), 1st Lt. James H. Kasler, and Maj. Winton W. Marshall. (Courtesy of *The Macomb Daily*.)

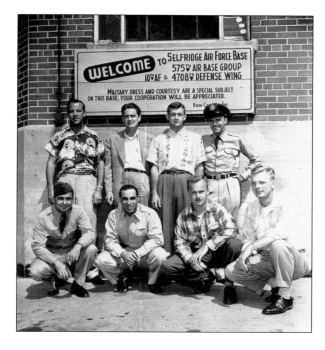

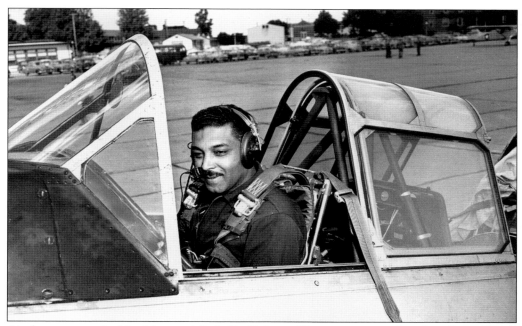

Air force reserve 2nd Lt. Vincent Mitchell of Mount Clemens prepares for take-off in a North American T-6G "Texan" trainer during summer exercises at Selfridge in 1953. Mitchell was a member of the 439th Fighter-Bomber Wing, known as the "Wolv-air-ines," and had served as a fighter pilot with the Tuskegee Airmen during World War II. (Courtesy of *The Macomb Daily*.)

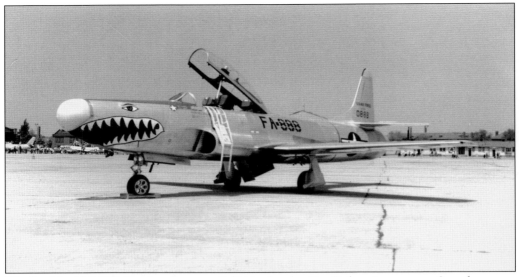

The Lockheed F-94B Starfire, flown at Selfridge by the 61st Fighter-Interceptor Squadron, was the air force's first all-weather interceptor and the first to have an afterburner. (Courtesy of William J. Balogh, via Menard.)

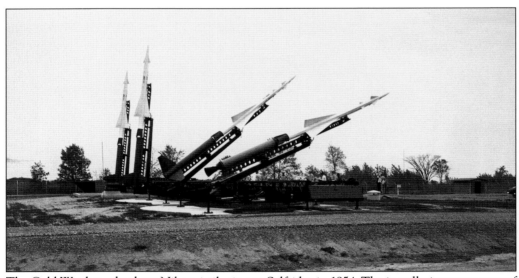

The Cold War brought three Nike missile sites to Selfridge in 1954. The installations were part of a 16-battery surface-to-air missile defense ring around the metropolitan Detroit area. Originally equipped with the Nike Ajax missile, shown here, they were converted to the Nike Hercules missile in 1958. The sites were deactivated in 1963 and 1971. (Courtesy of *The Macomb Daily*.)

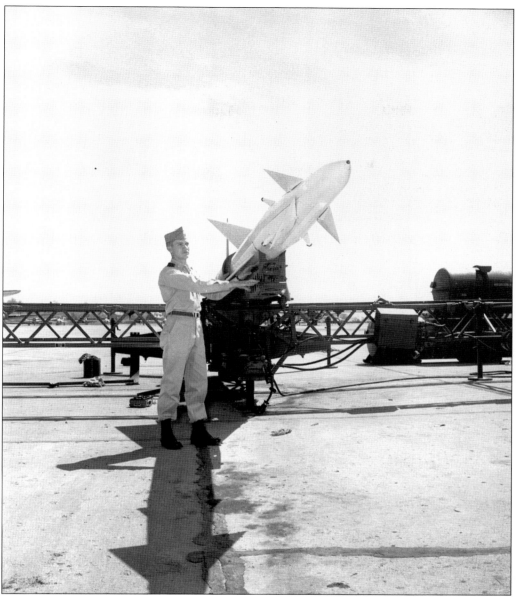

Lt. Floyd G. Judah, commander of Battery C, 516th AAA Missile Battalion at Selfridge, shows off a Nike Ajax missile during an Armed Forces Day open house at the base in 1954. (Courtesy of *The Macomb Daily*.)

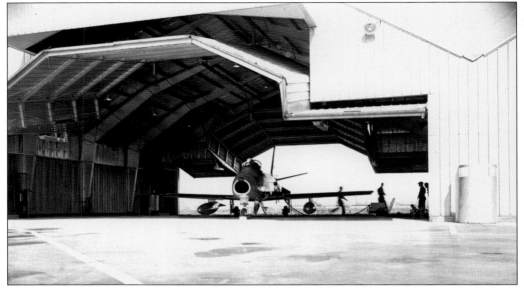

A North American F-86 Sabre is shown in one of the alert hangars in 1953. Alert "barns" were used by interceptor aircrew and maintenance personnel at Selfridge from the beginning of the Cold War era until 1969, and again by the Michigan Air National Guard from 1972 to 1990. The terrorist attacks of 2001 once again returned crews to these facilities. (Courtesy of *The Macomb Daily*.)

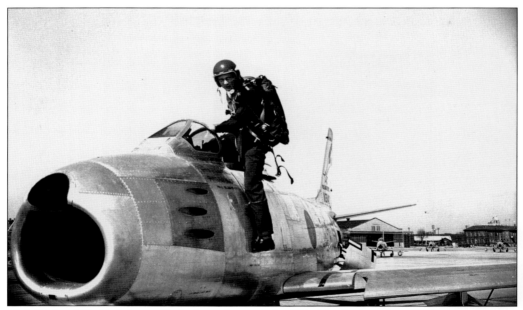

Maj. Richard D. Creighton climbs into the cockpit of his North American F-86E Sabre during an alert exercise at the base in 1953. Such exercises were designed to maintain a state of readiness that would allow fighters to be airborne within minutes after an alert was sounded. Major Creighton scored a combined seven air victories during his service in World War II and Korea. (Courtesy of *The Macomb Daily*.)

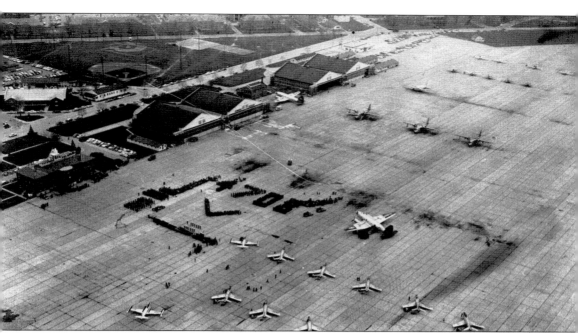

Pilots of the 13th Fighter-Interceptor Squadron saw this welcome waiting for them on the flight line at Selfridge when they returned victorious from a skills contest at Otis Air Force Base, Massachusetts, in April 1954. The men had just won the Eastern Air Defense Force rocket gunnery championship, and as they approached their home field, base personnel on the ground spelled out the numerals of their parent organization, the 4708th Air Defense Wing. (Courtesy of *The Macomb Daily*.)

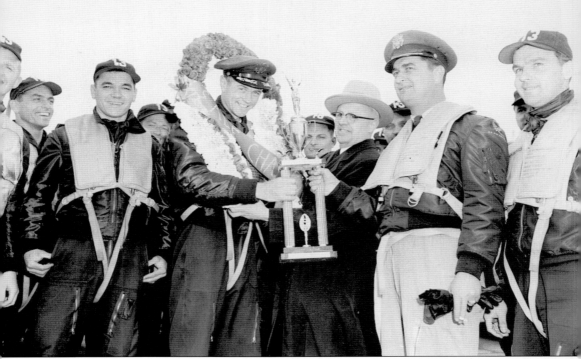

Proudly displaying their rocket gunnery trophy and receiving congratulations are the pilots of the 13th FIS championship team. Shown from left to right are Capt. Richard River, Base Commander Col. William A. Tope, Frank J. Munt of the Mount Clemens Board of Commerce, 4708th Air Defense Wing Commander Col. George B. Greene (1914–1998), and 13th FIS Commander Raymond Janeczek. (Courtesy of *The Macomb Daily*.)

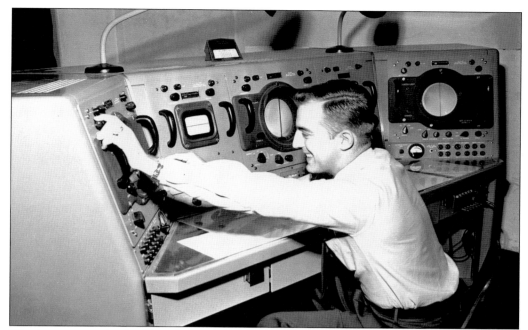

Weather patterns in the Great Lakes region often present challenges to aviators. Lt. Richard A. Winkenwerder of Detachment 14, 12th Weather Squadron, is shown manning the weather radar scopes at Selfridge in 1956. (Courtesy of *The Macomb Daily*.)

A1C John Mavis holds a 2.75-inch FFAR "Mighty Mouse" rocket of the type carried on the North American F-86 Sabre. On May 10, 1956, 22 of these rockets were accidentally fired from an F-86D on the ground at Selfridge, spraying areas on the base and a residence in neighboring Harrison Township. Three buildings were damaged in the mishap, and three airmen were injured. (Courtesy of *The Macomb Daily*.)

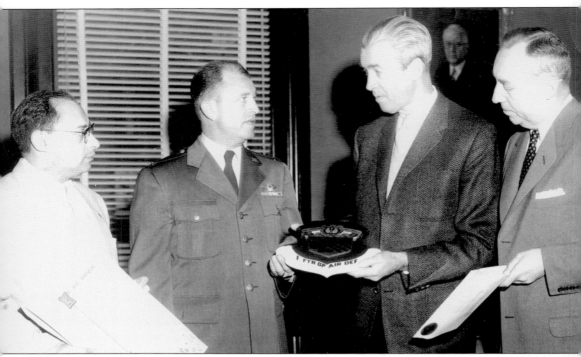

First Fighter Group welcomed a celebrity member in March 1957 when Brig. Gen. James M. "Jimmy" Stewart (1908–1997) came to town and was made an honorary member of the organization. The general, who had served as a bomb group commander in Europe during World War II, was in town in his movie star role to attend the Detroit opening of his film *The Spirit of St. Louis*, in which he portrayed Selfridge alumnus Charles A. Lindbergh. Shown with Stewart, from left to right, are Detroit Police Commissioner Edward S. Piggins (1906–1972), Selfridge Base Commander Col. Glenn E. Duncan (1918–1998), and Jerome Green, regional vice president of the Air Force Association.

Five

A Decade of
Transition

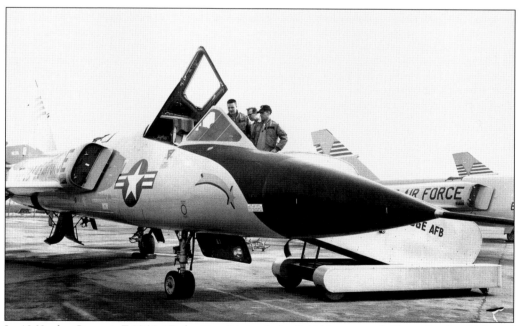

In 1960, the Convair F-106A "Delta Dart" joined the Selfridge arsenal. Flown by the 94th and 71st Fighter-Interceptor Squadrons, the Delta Dart could be armed with the Falcon air-to-air guided missile or the Genie nuclear-tipped rocket. Shown here from left to right are Lt. George Fox, *Daily Monitor-Leader* reporter Maury A. Vincent, and Capt. Stephen True. (Courtesy of *The Macomb Daily*.)

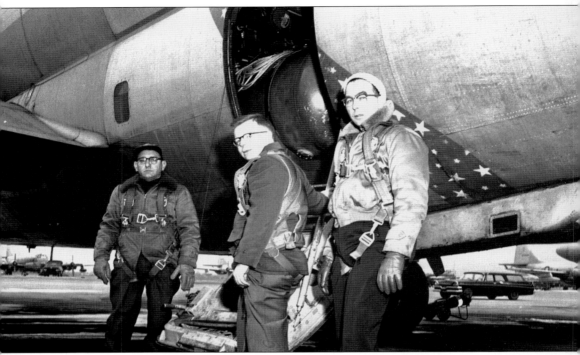

The 4045th Air Refueling Wing of the Strategic Air Command (SAC) became a tenant at Selfridge in July 1960, bringing with it the Boeing KC-97 "Stratotanker." The KC-97 was powered by piston engines running on gasoline but carried jet fuel in its tanks to accomplish its airborne refueling mission. In this view, from left to right, Mount Clemens citizens Robert A. Klein, Bill Martin, and Gerald Bersma prepare to take a goodwill flight aboard the giant tanker. (Courtesy of *The Macomb Daily*.)

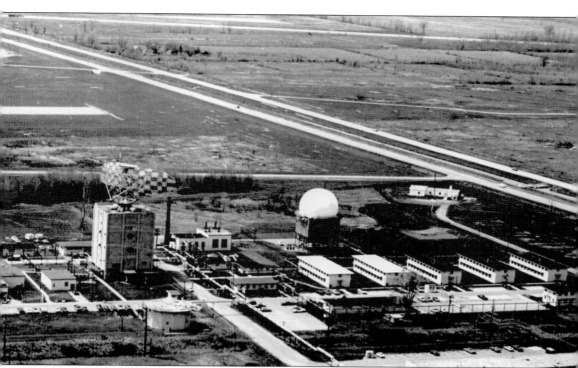

A sight visible for miles and a landmark for boaters on Lake St. Clair was the large FPS-35 checkerboard radar antenna, built for the 661st Radar Squadron in 1960. This antenna, which weighed 70 tons, scanned for threats in the horizontal and when coupled with the height finder FPS-26 radar inside the geodesic dome, provided range, distance, and elevation information to the army's Nike missile defense units at Selfridge and in the Detroit area. The 661st was inactivated in July 1974, but the six-story structure that supported the FPS-35 antenna remains, as do four of the small buildings. The area is now home to the Selfridge Military Air Museum.

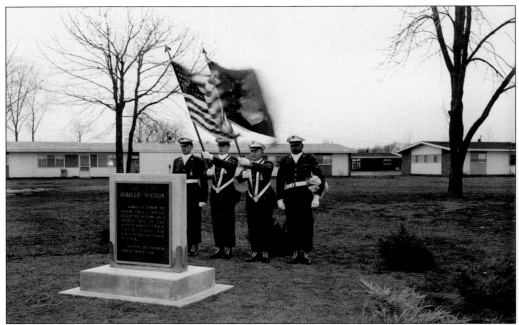

In 1961, Selfridge dedicated a Capehart Housing project on Sugarbush Road in adjacent Chesterfield Township. The development, consisting of 380 residence units, was named Sebille Manor in memory of Maj. Louis J. Sebille (1915–1950), a Michigan native who lost his life in a combat mission during the Korean War and was posthumously awarded the Medal of Honor. (Courtesy of *The Macomb Daily*.)

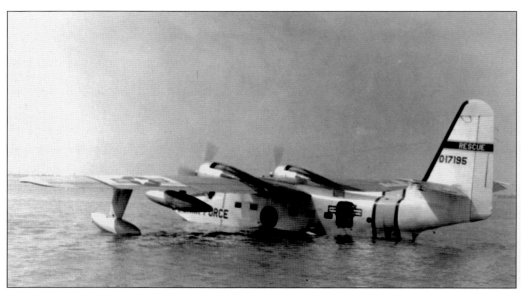

A Grumman SA-16 Albatross, flown by the air force reserve's 305th Aerospace Rescue and Recovery Squadron (ARRS), performs a retrieval exercise on Lake St. Clair in 1962. The amphibious craft was used for search and rescue work by the air force, navy, and Coast Guard during the Vietnam era. (Courtesy of William J. Balogh, via Menard.)

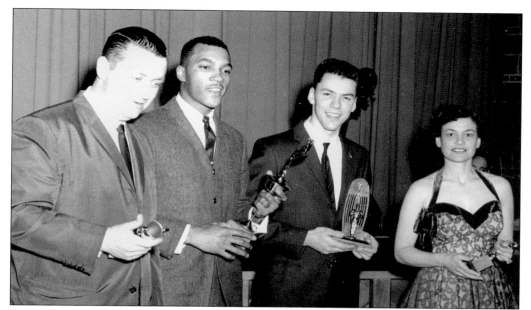

Recreation at Selfridge took many forms, among them a base talent competition. Shown here are the winners of a talent contest sponsored by the Personnel Services section in 1962. From left to right are Sgt. Jack R. Davis, master of ceremonies; A3C Michael E. Roberts, first place for male vocalist; A2C R. Wyatt MacGaffey, first place for instrumental solo; and TSgt. Elizabeth M. Forte, first place WAF vocalist.

Selfridge airmen paraded smartly down Macomb Street in Mount Clemens on "Selfridge Air Force Base Day" in July 1962. The parade and a USO show were hosted by the city to show appreciation for the air force. The base reciprocated by inviting the public to a three-day carnival. (Courtesy of *The Macomb Daily.*)

A Selfridge Reserve unit, the 63rd Troop Carrier Squadron of the 403rd Troop Carrier Wing, distinguished itself in 1962 by placing in an Air Force Association airdrop contest. The crew included, from left to right, Lt. Col. George L. Kittle, Maj. Michael McLeod, Capt. Hugh Graham, and SSgt. Gregory Garcia. (Courtesy of *The Macomb Daily*.)

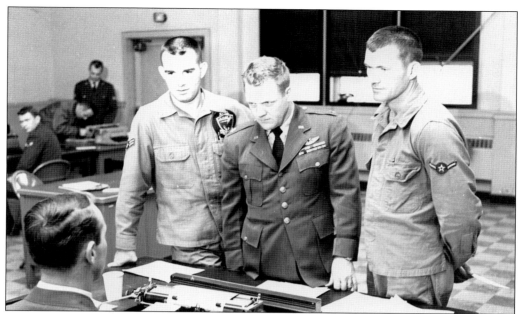

Cold War tensions affected reservists at Selfridge and across the nation in October 1962, when units were mobilized in response to the Cuban Missile Crisis. Members of the 403rd Troop Carrier Wing reported for duty at Selfridge on October 29. Shown here, being processed by A3C Robert Morgan, are, from left to right, A2C Charles D. Christie, Maj. William Denison, and A3C James Rodgers. (Courtesy of *The Macomb Daily*.)

The 403rd Troop Carrier Wing (AFRES) flew the Fairchild C-119 "Flying Boxcar" during its early years at Selfridge. In 1963, the unit airlifted a load of medical supplies to a remote clinic in Central America, typical of the type of humanitarian missions the 403rd and its airlifters were often called upon to handle. (Courtesy of *The Macomb Daily*.)

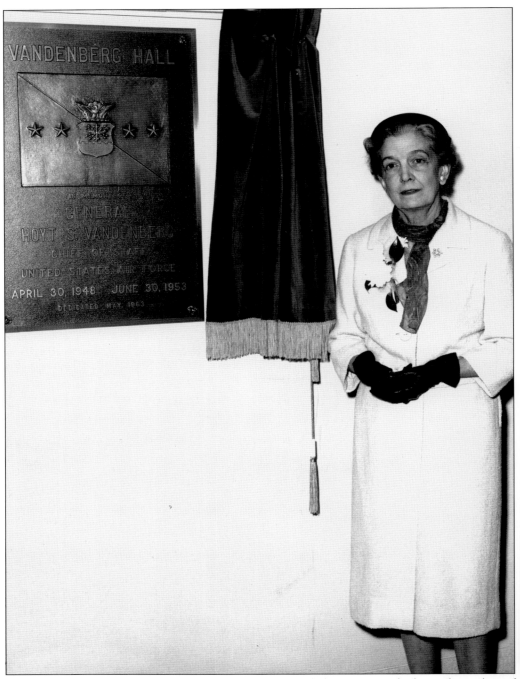

On May 3, 1963, the Selfridge community welcomed Gladys Rose Vandenberg, the widow of former Chief of Staff Gen. Hoyt S. Vandenberg (1899–1954) of the air force, to dedicate the new recreation center and service club, Vandenberg Hall. Gladys had made her own contribution to the military community during her husband's term as air force chief of staff when she founded the "Arlington Ladies" program at Arlington National Cemetery.

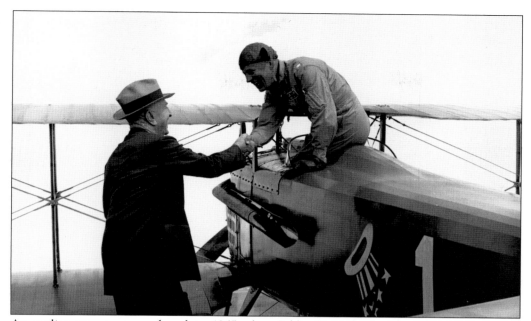

An earlier era was remembered in 1965 when Eddie V. Rickenbacker (1890–1973), former ace of the 94th Pursuit Squadron, visited the base to watch First Fighter Wing commander Col. Converse B. Kelly (1918–2000) pilot a restored SPAD that had been decorated with the 94th's historic Hat-in-the-Ring insignia. Rickenbacker is shown congratulating Col. Kelly after his flight. (Courtesy of *The Macomb Daily*.)

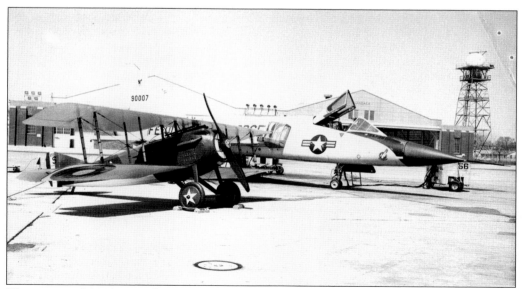

The renovated SPAD proudly took its place beside its modern counterpart, the Convair F-106A Delta Dart, on the Selfridge ramp. The SPAD was later sent to the National Museum of the Air Force in Dayton, Ohio, for permanent display. (Courtesy of *The Macomb Daily*.)

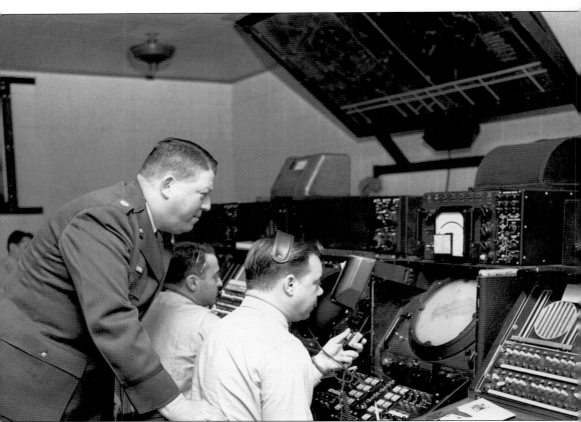

The 2031st Airway and Air Communications Service (AACS) Squadron had a long history at Selfridge. Charged with operating and maintaining navigational aid facilities such as the control tower and Radar Approach Control (RAPCON), the squadron's equipment changed with the march of technology. Shown testing new equipment in 1960 is Maj. William S. Treacy, Squadron Commander (standing), with Capt. Benjamin Zum (left) and TSgt. Howard A. Bates. The 2031st AACS became the 2031st Air Force Communications Service (AFCS) Squadron in 1961. (Courtesy of *The Macomb Daily*.)

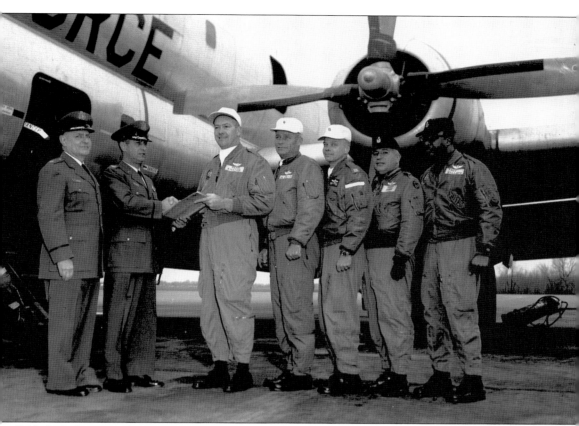

Selfridge's days as a Strategic Air Command (SAC) base ended in December 1965, when the 4045th Air Refueling Wing was deactivated. The crew of the final SAC flight from Selfridge, which departed on December 16, 1965, is shown at the right, receiving a send off from two commanders. The crew included, from left to right, Major Williams, Major Collins, unidentified, Master Sergeant Cook, and Technical Sergeant Billups. (Courtesy of *The Macomb Daily*.)

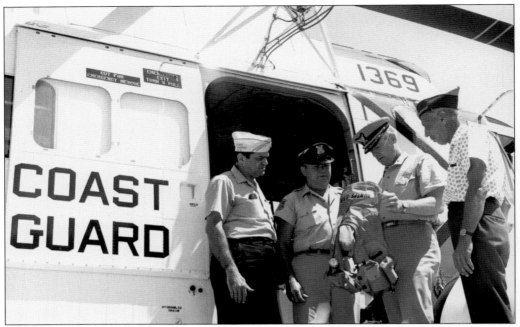

The U.S. Coast Guard became a tenant unit at Selfridge in the summer of 1966, when its Air Station Detroit moved to the base. Representatives of the AmVets were among the first citizens to greet the new organization. Shown here from left to right are Andrew J. Skinner, Larry Spikes, Coast Guard Commander James W. Swanson, and Alphonse Charlan. (Courtesy of *The Macomb Daily*.)

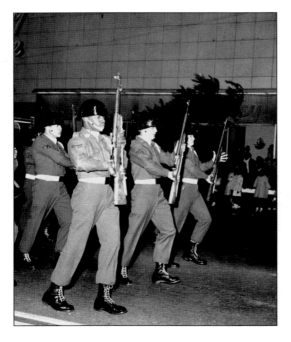

The Selfridge drill team, Ambassadors in Blue, performs for enthusiastic crowds at the Mount Clemens Farm-City Week celebration in 1966.

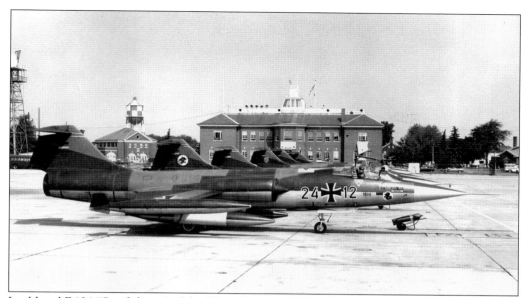

Lockheed F-104 "Starfighters" of the West German Luftwaffe visited Selfridge during the base's 50th anniversary celebration in July 1967. The West German Luftwaffe flew a large number of F-104s and received most of their training in the aircraft at Luke AFB, Arizona.

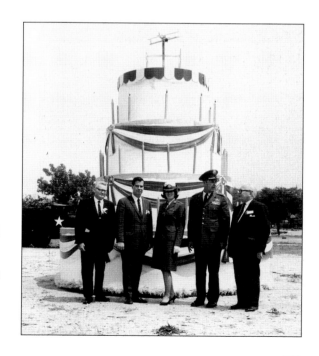

In honor of the concurrent 50th anniversaries of the First Fighter Wing and Selfridge Air Force Base, a 12-foot-high birthday cake was erected in July 1967. A three-day celebration was the highlight of the summer. Shown from left to right are R. Eugene Inwood, Charles Parks, A2C Martha Santora, Col. Kenneth E. Rosebush, and George Priehs. (Courtesy of *The Macomb Daily*.)

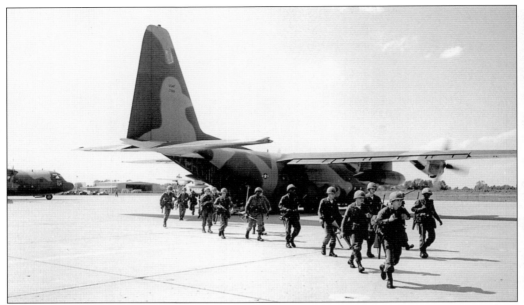

The civil disturbances in Detroit during the summer of 1967 saw the airlift of thousands of paratroopers and supporting personnel from Fort Campbell, Kentucky. The troops were sent to Selfridge to assist police and Michigan National Guard units in restoring order in Detroit. (Courtesy of *The Macomb Daily*.)

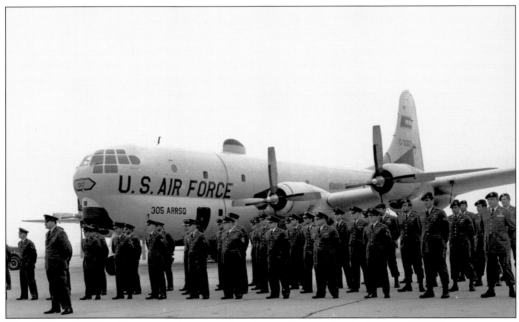

The 305th ARRS, a Reserve unit, was ordered to active service in January 1968 in response to the USS *Pueblo* incident. *Pueblo*, a U.S. Navy vessel, had been captured by North Korea and her crew held prisoner for 11 months. The 305th stood down from active duty on July 19, 1969, in the ceremony shown here. (Courtesy of *The Macomb Daily*.)

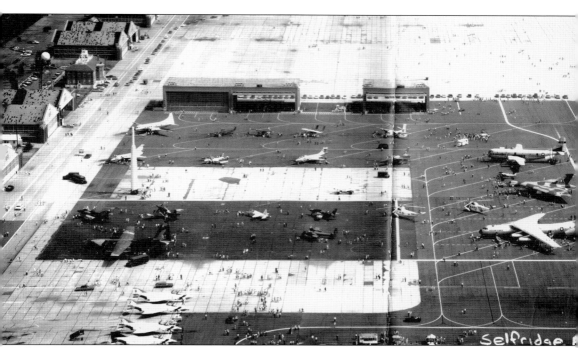

This bird's-eye view of the airfield was taken during a September 1969 air show and open house by a Republic RF-84F "Thunderflash" flown by the Michigan Air National Guard. The first modern jet designed for photo reconnaissance, the RF-84F was equipped with a combination of aerial cameras that allowed close-up photography of individual targets.

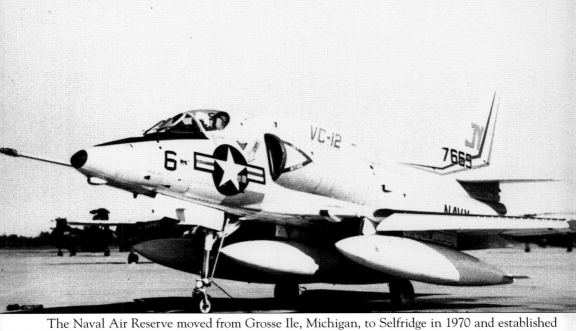

The Naval Air Reserve moved from Grosse Ile, Michigan, to Selfridge in 1970 and established the Naval Air Facility Detroit. With the navy's arrival, the air force hosts at Selfridge became accustomed to seeing different aircraft on the ramp, among them this McDonnell-Douglas A-4 "Skyhawk," used extensively as a trainer.

The Naval Air Facility made its new home at Selfridge by renovating an area on the west side of the base that had been left vacant upon the departure of the 4045th ARW. Shown here, in a view looking north, is the west ramp area as it was being remodeled to accommodate navy operations.

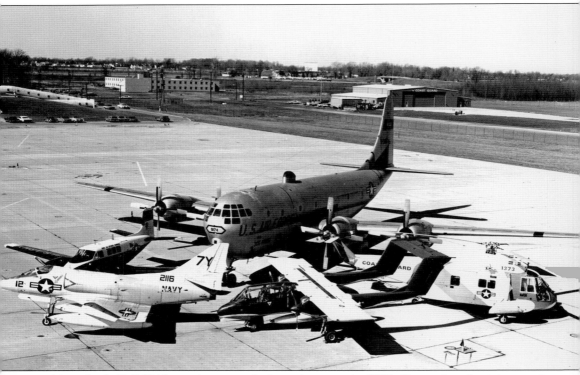

Aircraft of all Selfridge units are parked on the ramp in 1970, illustrating the joint services installation to which the base was transitioning. In the center of the group is a Boeing KC-97 Stratotanker of the 305th ARRS (AFRES). From left to right around the KC-97 are Cessna U-3 "Administrator" of the 70th Division (Training), USAR; McDonnell-Douglas A-4 Skyhawk, of Squadron VC-12, USNR; North American OV-10 "Bronco" of Squadron VMO-4, USMCR; and a Sikorsky HH-52 "Sea Guard" of the U.S. Coast Guard Air Station Detroit.

Six

THE AIR NATIONAL GUARD ERA

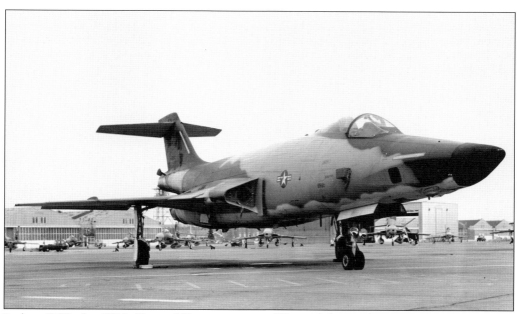

In late 1970, the 127th Tactical Reconnaissance Wing of the Michigan Air National Guard began its move to Selfridge Air Force Base. The wing was considered in place on January 1, 1971, with two squadrons flying the Republic RF-84F Thunderflash. Two weeks later, the 127th began conversion to the McDonnell RF-101 "Voodoo," shown here.

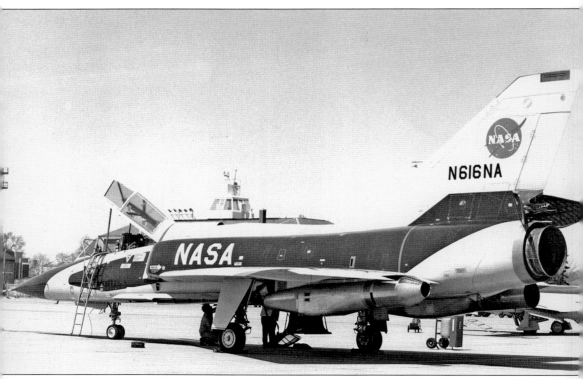

A most unusual Convair F-106B Delta Dart is shown visiting home base. This aircraft, given on long-term loan from the First Fighter Wing's 94th Fighter-Interceptor Squadron to NASA, was specially modified for testing and had two additional jet engines mounted under the wings. Flown for years into thunderstorms for weather tests, the airplane was struck by lightning more than 700 times before retiring to the Virginia Air and Space Museum in 1991. (Courtesy of Bill Balogh Jr.)

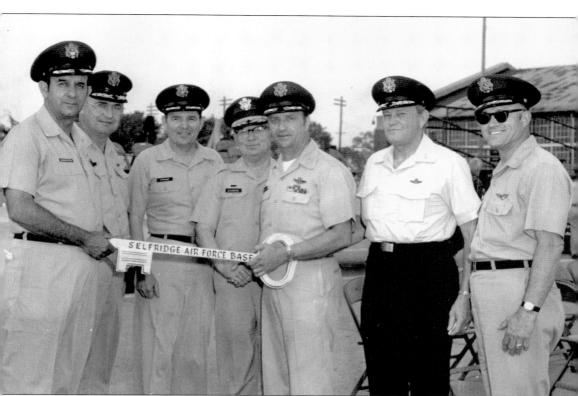

July 1, 1971, was a landmark day in the history of the field, as Selfridge Air Force Base was transferred to the Michigan Air National Guard and officially became Selfridge Air National Guard Base. Col. Kenneth I. Gunnarson (1923–2005), USAF Base Commander, turned the ceremonial key to the base over to Lt. Col. Rudolph D. Bartholomew of the Michigan Air National Guard. Shown here, from left to right, are Colonel Gunnarson, Maj. Gen. John A. Johnston, Col. Howard Strand, Maj. Gen. Clarence C. Schnipke (1912–1995), Lieutenant Colonel Bartholomew, Maj. Gen. I. G. Brown, and Brig. Gen. Stanley Vihtelic.

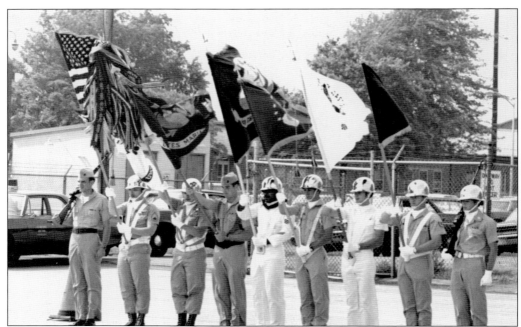

An all-services color guard took part in the historic change of command ceremony transferring the base from the air force to the guard, representing all of the organizations that would now be a part of Selfridge Air National Guard Base.

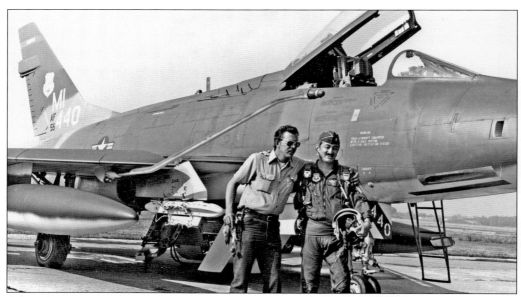

After the MI ANG's 107th Tactical Reconnaissance Squadron became a Tactical Fighter Squadron in June 1972, the unit began flying the North American F-100D "Super Sabre." Shown here with the last F-100D to leave Selfridge is Maj. Donald G. Miller, pilot, and MSgt. Bill Cousins, crew chief. This aircraft, tail number 56-440, is now at the National Air and Space Museum. (Courtesy of Bill Balogh Jr.)

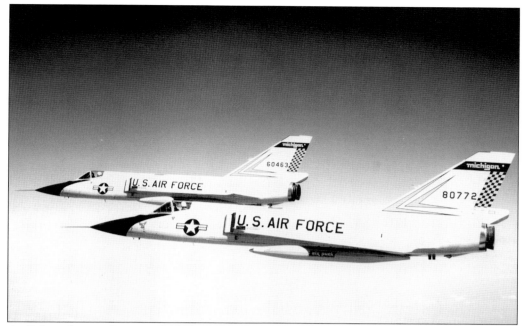

A flight of two Convair F-106A Delta Darts proudly wears the markings of the 171st Fighter-Interceptor Squadron of the 191st Fighter-Interceptor Group. When the 191st received its F-106 aircraft, the unit adopted the nickname "Six Pack" and assumed the air defense alert mission at Selfridge. (Courtesy of Lt. Col. Douglas Barbier.)

Col. Don Reid, commander of the 191st Fighter-Interceptor Group, inspects the air guard emblem on the tail of the first Convair F-106 Delta Dart delivered to the group. (Courtesy of Michigan Air National Guard.)

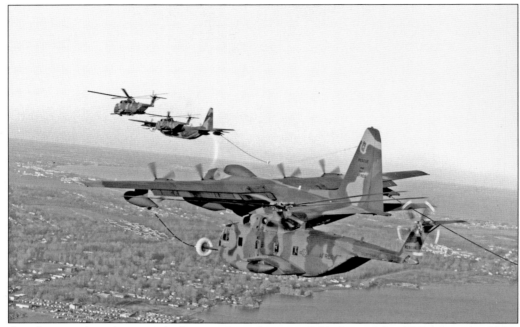

Another search-and-rescue platform made its home at Selfridge in May 1972 when the 305th Aerospace Rescue and Recovery Squadron began flying the Lockheed HC-130H "Hercules," shown here refueling one of the squadron's Sikorsky HH-3 "Jolly Green Giant" helicopters. (Courtesy of MSgt. James O. Tenney.)

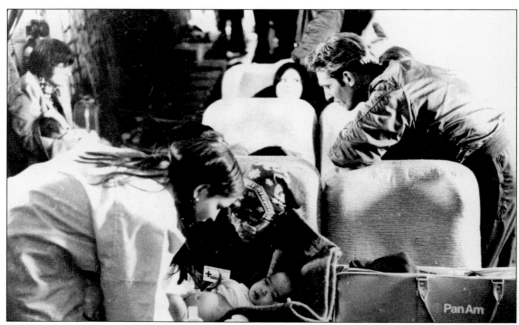

In April 1975, the 305th ARRS participated in Operation Babylift, by bringing South Vietnamese orphans from California to Metropolitan Airport in Michigan. Master Sergeant Knox is shown assisting in the photograph.

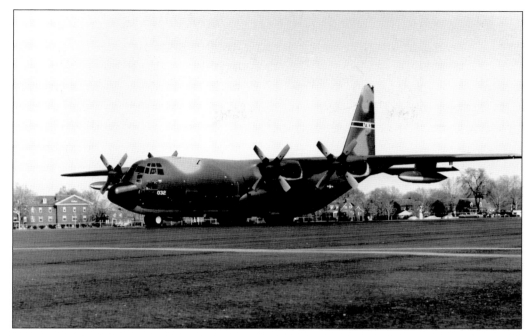

A familiar airlifter in the Selfridge skies was the Lockheed C-130A Hercules, flown by the air force reserve's 927th Tactical Airlift Group, which had originally located at the base in 1963 as the 927th Troop Carrier Group.

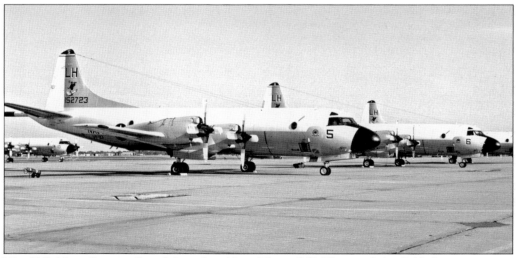

The U.S. Navy Reserve Patrol Squadron Nine Three (VP-93) joined the Selfridge community in 1976, along with its Lockheed P-3A "Orions," which were antisubmarine patrol craft. The P-3s were flown at Selfridge until 1994, when the squadron was decommissioned. (Courtesy of SMSgt. Jim Koglin.)

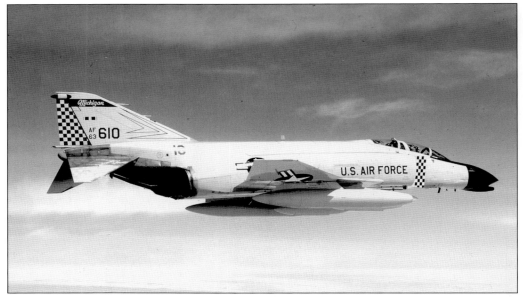

A new fighter aircraft arrived at Selfridge in May 1978, when the 171st Fighter-Interceptor Squadron began flying the McDonnell F-4C "Phantom II." (Courtesy of Lt. Col. Douglas Barbier.)

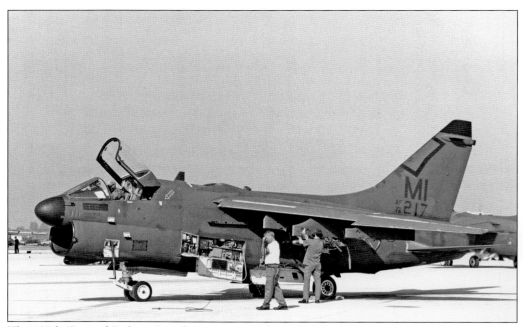

The 107th Tactical Fighter Squadron converted from the North American F-100 Super Sabre to the Vought A-7D "Corsair II" in early 1979. This aircraft is being prepared for flight during the Sentry Wolverine exercise in 1988. (Courtesy of Tony Cassaman.)

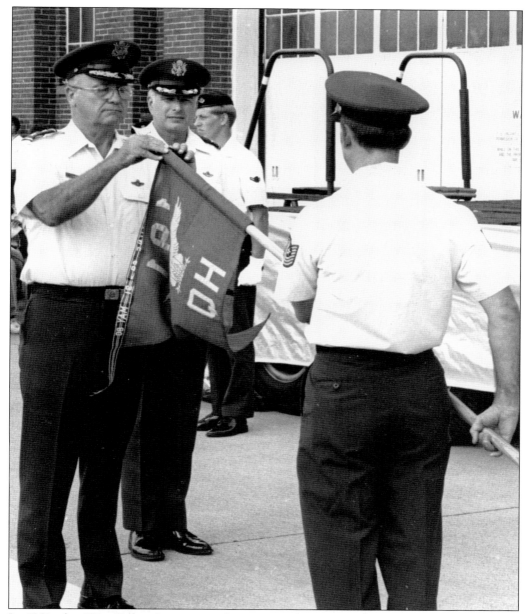

In 1981, the 191st Fighter-Interceptor Group won the Air Force Outstanding Unit Award. MSgt. Thomas C. Craft holds the 191st FIG guidon as the AFOUA streamer is being affixed by Maj. Gen. John A. Johnston, while Col. Lloyd E. Harsh Jr., 191st commander, looks on.

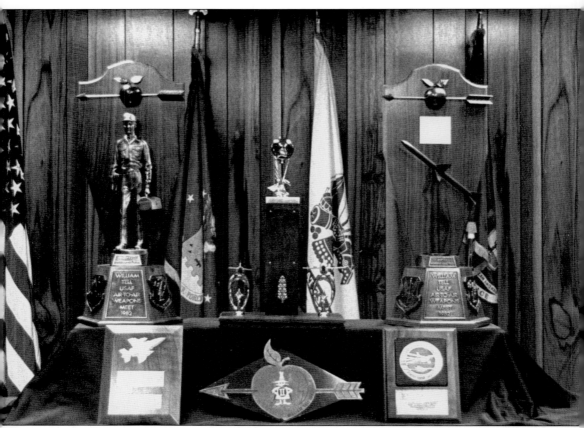

Personnel of the 191st Fighter-Interceptor Group were proud to bring home six awards from the 1982 William Tell air-to-air weapons meet at Tyndall Air Force Base, Florida. Their honors included the Best F-4 Maintenance Team Trophy, Best F-4 Weapons Loading Trophy, Best Aircraft Appearance Plaque, Missile Plaque, and the Apple Splitter Trophy and Plaque.

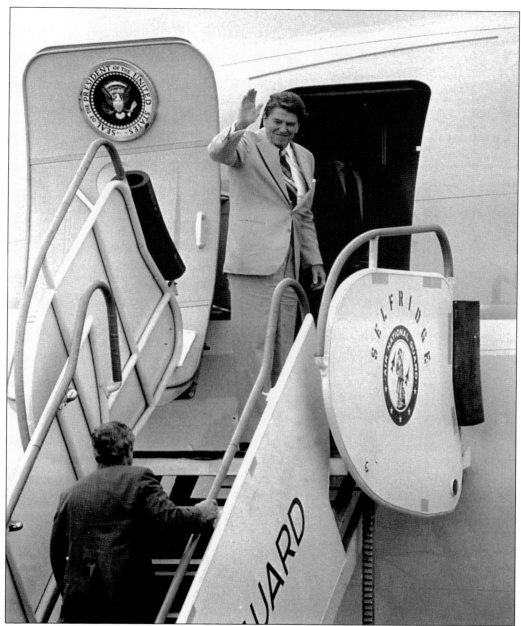

Selfridge has received many distinguished visitors over the years, but the arrival of the commander in chief is always a noteworthy occasion. In July 1984, Pres. Ronald Reagan (1911–2004) stopped at the base during his tour of Michigan's auto industry sites, including the General Motors Technical Center in Warren. (Courtesy of *The Macomb Daily*.)

Members of the 191st Consolidated Aircraft Maintenance Squadron's munitions crew practice loading missiles on a McDonnell F-4C Phantom II. (Courtesy of SMSgt. Jim Koglin.)

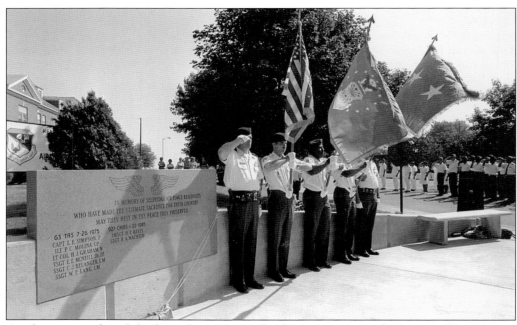

A solemn reminder of the hazardous nature of military aviation is this memorial on George Avenue, dedicated in 1985 to the air force reserve members from Selfridge who gave their lives in service to their country. (Courtesy of *The Macomb Daily*.)

November 4, 1986, marked the end of an era when this Lockheed T-33A, which had been flown by the guard's 171st Fighter-Interceptor Squadron since 1955, was sold to the Mexican Air Force. This aircraft holds the record for the longest continuous service with a single unit (31 years) for any tail number in the combined history of the air force, air force reserve, and Air National Guard. (Courtesy of Lt. Col. Douglas Barbier.)

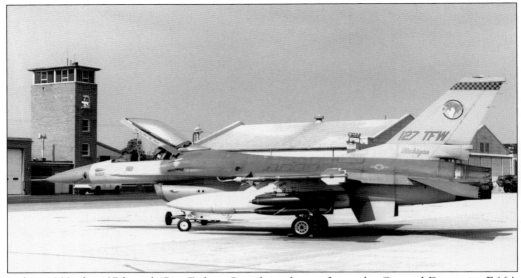

In late 1989, the 107th and 171st Fighter Squadrons began flying the General Dynamics F-16A "Fighting Falcon." In 1991, elements of these units would participate in Operation Desert Storm, which ended the Iraqi occupation of Kuwait. (Courtesy of Jerry Geer.)

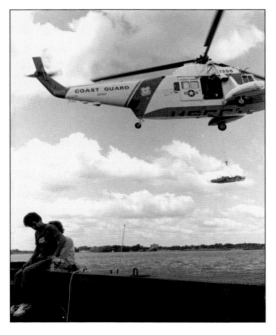

The Coast Guard Air Station Detroit flew the Sikorsky HH-52 Sea Guard helicopter on search and rescue missions in its primary area of responsibility, the Eastern Great Lakes maritime region.

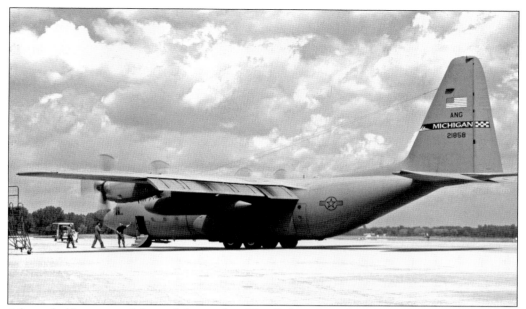

After a half century of flying fighters, the 171st Fighter Squadron's mission and aircraft were changed in 1994. Now the 171st Airlift Squadron, it began flying the Lockheed C-130E Hercules. The 171st provided airlift for Operation Iraqi Freedom beginning in 2003. (Courtesy of SMSgt. Jim Koglin.)

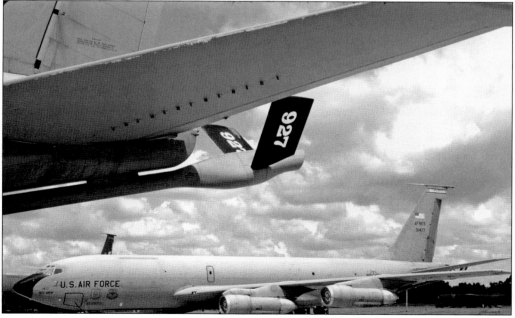

Another aircraft and mission change came in 1994, when the 927th moved from the Lockheed C-130 Hercules to the Boeing KC-135E Stratotanker, shown here on the flight line. Now the 927th Air Refueling Wing, the proud unit flies missions in hot spots around the world. (Courtesy of SMSgt. Jim Koglin.)

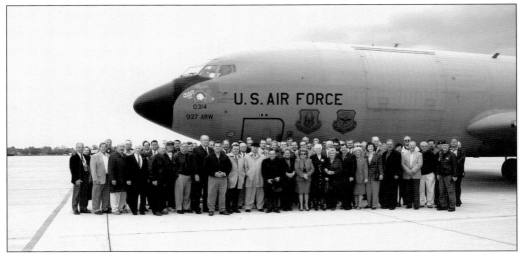

The Selfridge Base Community Council participated in the 2003 dedication ceremony for the Boeing KC-135R Stratotanker, as the 927th transitioned to the newer tanker model. The Base Community Council has worked to foster harmonious relationships among Selfridge and its neighbors for more than half a century and is one of the largest and most active community councils in the nation. (Courtesy of TSgt. Scott LaForest, 927th ARW Public Affairs.)

TSgt. Johnny White of the 927th Air Refueling Wing explains the work of a boom operator aboard a Boeing KC-135 Stratotanker to a civilian observer. The observer was participating in a special orientation program in which reservists demonstrate their military duties to their civilian employers. (Courtesy of TSgt. Scott LaForest, 927th ARW Public Affairs.)

The most recent addition to the Selfridge community came in 2003, when the Michigan Army National Guard's Detachment 1, Company 6, 185th Aviation, moved to the base from Grand Ledge, bringing along its Boeing CH-47 "Chinook" helicopters. This unit, nicknamed the "Beast Masters," flew numerous combat support missions during a 12-month deployment for Operation Iraqi Freedom. (Courtesy of Michigan Army National Guard.)

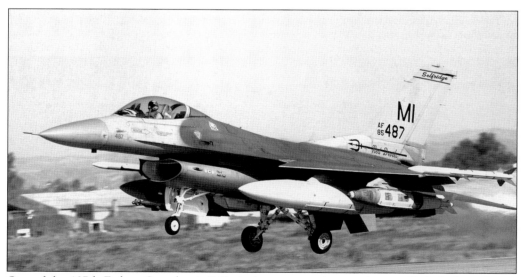

One of the 107th Fighter Squadron's F-16s is shown operating at a base in Kirkuk, Iraq, during Operation Iraqi Freedom.

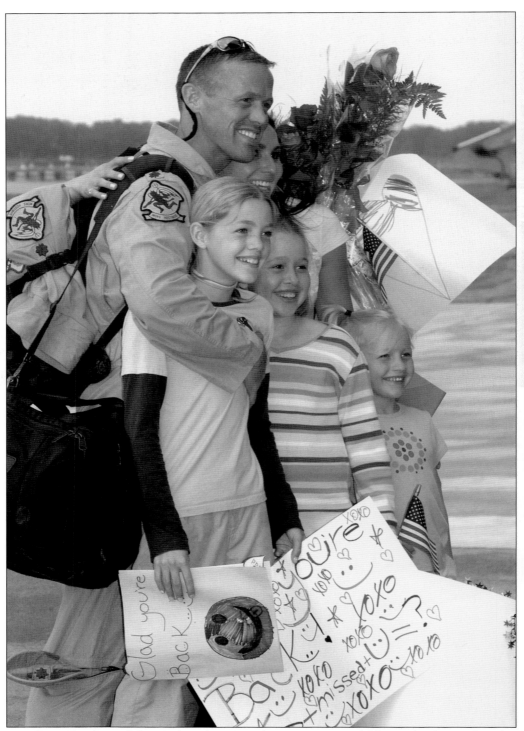

Maj. Brian Bracken of the 107th Fighter Squadron receives tearful hugs of welcome from his family upon his return home after a deployment in support of Operation Iraqi Freedom.

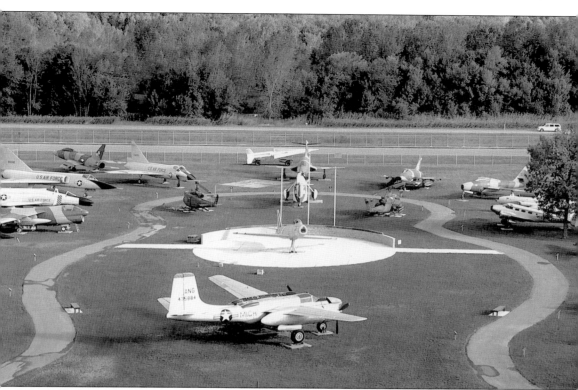

The Selfridge Military Air Museum preserves the history of Selfridge and the Michigan Air National Guard through its air park and museum exhibits. Founded in 1975 under the leadership of Col. Robert A. Stone (1918–1996), the museum has grown from modest beginnings to encompass several buildings and includes 28 aircraft on static display.

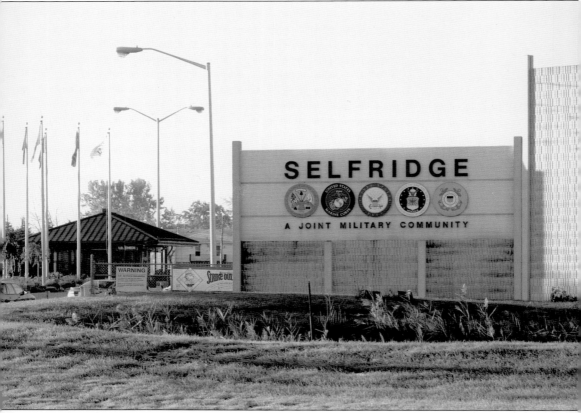

Today, the main gate of Selfridge Air National Guard Base reflects its modern role in the nation's defense. Just as it led the way as a prototype military aviation school and airfield in 1917, Selfridge again stands as a successful example of the new type of military installation—a joint-use facility hosting multiple branches of the armed services. With the 127th Wing, Michigan Air National Guard serving as host, Selfridge is home to units from the U.S. Army, U.S. Air Force, U.S. Navy, U.S. Marine Corps, U.S. Coast Guard, and the U.S. Border Patrol. (Courtesy of *The Macomb Daily*.)

INDEX OF AIRCRAFT IMAGES

DISCOVER THOUSANDS OF LOCAL HISTORY BOOKS FEATURING MILLIONS OF VINTAGE IMAGES

Arcadia Publishing, the leading local history publisher in the United States, is committed to making history accessible and meaningful through publishing books that celebrate and preserve the heritage of America's people and places.

Find more books like this at
www.arcadiapublishing.com

Search for your hometown history, your old stomping grounds, and even your favorite sports team.